Lake Ronkonkoma

Dale Spencer and Janet Rischbieter

ARCADIA
PUBLISHING

Published by Arcadia Publishing
Charleston, South Carolina

Printed in the United States of America

Library of Congress Control Number: 2014950863

For all general information contact Arcadia Publishing at:
Telephone 843-853-2070
Fax 843-853-0044
E-mail sales@arcadiapublishing.com
For customer service and orders:
Toll-Free 1-888-313-2665

Visit us on the Internet at www.arcadiapublishing.com

This book is dedicated with loving memory to our mothers, Anna P. Spencer and Florence Ann Rischbieter, for all their love and encouragement.

POSTCARD HISTORY SERIES

Lake Ronkonkoma

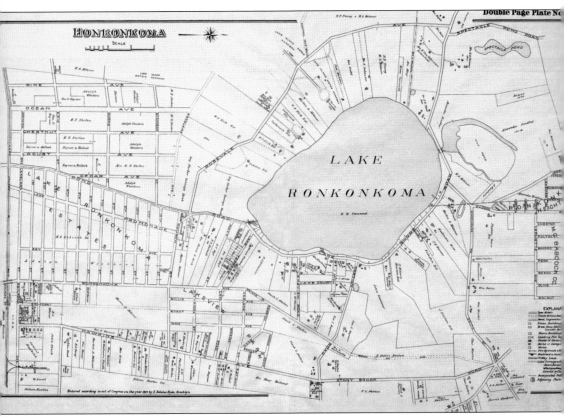

This survey map dated 1917 shows who owned the various parcels in the lake area. The map also lists all buildings on each property and their exact location. This map hung on the wall of local attorney Francis Gianconne's office for decades. (Courtesy of the Lake Ronkonkoma Historical Society.)

ON THE FRONT COVER: Duffield's West Park Beach was one of the grand pavilions built along Lake Ronkonkoma in the 1920s. Some of the many attractions were rowboats and canoes for rent, a 12-passenger speedboat, a 36-seat tour boat, two diving platforms, a large water wheel, and a floating pontoon dock, which was a great place to pose for a group photograph. (Courtesy of the Lake Ronkonkoma Historical Society.)

ON THE BACK COVER: The Raynor's Beach Restaurant was one of the early additions to the ever-growing Raynor's Beach complex. The restaurant, which opened for business on the east side of Lake Ronkonkoma in 1928, was built on Lake Shore Drive, right across from the beach. Raynor's Beach Restaurant was two stories. It featured a tavern and a large upstairs dining room. (Courtesy of the Lake Ronkonkoma Historical Society.)

CONTENTS

Acknowledgments

The authors would like to thank the following people for their input with this project: Helen Hethy Mulvihill, Jim Brown, Owen Wister, Matt Balkham, Jason Norman, Steve Lucas, Fredrick Kraics, Stan Mcgroary, Les Hanak, and the Lake Ronkonkoma Historical Society.

We would also like to thank Gillian Nicol and Jeff Ruetsche at Arcadia Publishing for all their help and patience during this project.

Dale would like to thank sister Wendy Sipos for love, support and endless enthusiasm for this project and Stephanie Gress for her friendship and support.

Janet would like to thank her sister Linda Raskin for a lifetime of love, support, and encouragement and brother Donald Rischbieter for always being there.

Unless otherwise noted, all images appear courtesy of the Lake Ronkonkoma Historical Society.

INTRODUCTION

The popular era of postcards began in the United States in the 1870s. In 1873, the US government printed and sold postcards with prestamped 1¢ postage. Private card producers were not allowed to use the word postcard on their cards. Private mailing, or printed matter cards as they were sometimes, called cost 2¢ to mail. An act of Congress in 1898 allowed 1¢ postage rates for privately produced cards. By the end of 1901, private cards could now be called postcards. Until 1903, the only writing allowed on the back of the postcards by law was the address. Messages had to be written on the front side; this is why many early photographic postcards had a large blank space around the image. Then, the divided back was created, with the address going on the right side and the message on the left. Sending postcards was so popular between June 1907 and June 1908 that 600 million postcards were mailed in the United States. The US population at the time was only a little over 80 million.

The collection of postcards and private mailing card images contained within this book offer a historical glimpse into the town of Lake Ronkonkoma, which is located in the geographic center of Long Island, about 50 miles east of New York City. By the 1870s, Lake Ronkonkoma, located in the wilderness of Long Island, had gained a reputation as a beautiful "out in the country" vacation destination. Wealthy travelers from New York City and Long Island traveled on the Long Island Railroad to the nearby Lakeland Station to vacation at the lake. The Lake Front Hotel, located on the east shore of the lake, catered to the every need of these well-heeled travelers.

In 1883, the railroad opened the Ronkonkoma station, and four new hotels rose up across the street from the new train station. Hundreds of people came to beautiful "Lake Ronkonkoma in the Pines" to enjoy its healthy, clean air and swim, boat, and fish in the sparkling waters of the lake. The area around Lake Ronkonkoma was still a small farming community with a population of about 200 at this time. A few local residents took in summer boarders for extra income. The lake was a tranquil place, mostly undeveloped except for a few small docks and boathouses built by local residents.

The construction of the Long Island Motor Parkway, the first limited-access highway for automobiles built in the United States, was an early signpost for the massive changes on the horizon for Lake Ronkonkoma. It ran from Queens County in New York City east to Lake Ronkonkoma. These changes would not only affect Lake Ronkonkoma, but American society as a whole. No one, including William K. Vanderbilt III, the man responsible for building the parkway, could recognize this in 1911 when the parkway construction reached the shores of Lake Ronkonkoma.

By the 1920s, with more Americans driving automobiles, the summertime brought thousands of visitors to Lake Ronkonkoma. Grand beach pavilions were built to serve the hordes of people, and land was sold for summer cottages, many of which eventually became year-round homes. The population of the town slowly started growing. The chapters of this book give a glimpse into the growth of the lake and the town throughout the 20th century—from a small town to a bustling summer resort.

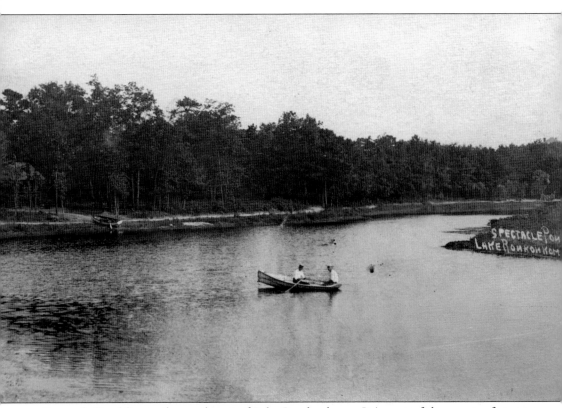

Spectacle Pond lies to the northwest of Lake Ronkonkoma. It is part of the group of streams, including the Great Swamp directly north of Lake Ronkonkoma, that feed water to the lake via the inlet. This 1924 postcard shows two men boating on the pond. Not much has changed here in the last century—the pond is still a popular local fishing spot.

One

THE EARLY DAYS

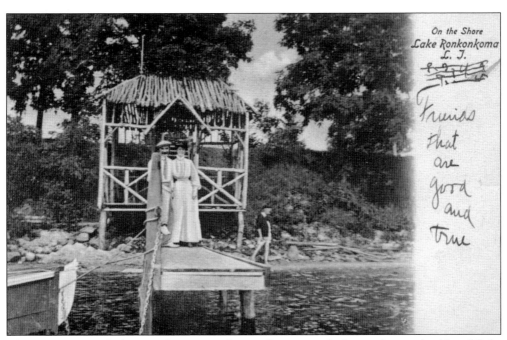

This 1908 postcard shows a happy couple standing on a dock on the north side of Lake Ronkonkoma. Word was spreading in the New York City region about the beauty and tranquility of this vacation spot in the pines. This card was manufactured in Germany, but in the next decade, the effects of World War I would end the tradition of finely produced postcards from Germany.

In the early 1900s, Lake Ronkonkoma was an area of just a couple hundred year-round residents. Local residents built small handmade docks for their fishing boats. In the summer, the population of the town would double, as wealthy New York City residents came to stay at the hotels that developed around the lake and around the Ronkonkoma railroad station. (Courtesy of Helen Hethy Mulvihill.)

The US postcard boom of the early 20th century inspired local photographers to create postcards displaying the rural beauty of Lake Ronkonkoma. This photographic postcard image captures the eastern shore of the lake looking south towards Young's Cove at the southeast corner of the lake in its natural state, around 1905. The two general stores in town sold many of these postcards to the growing number of New York City residents coming to the area for summer vacations.

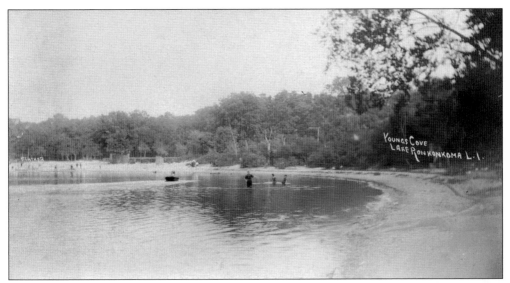

Smithtown photographer Robert S. Feather took scores of photographs of Long Island life. He opened a shop in Smithtown where he produced postcards and handsomely framed photographs for sale. This is a 1905 Robert S. Feather–produced photographic postcard of Young's Cove. Young owned most of the land at this area of the lake, but a section of beach just to the north was owned by the Hoyt family. It was used by local residents as well as leased on a yearly basis to Fitz-Greene Hallock for use by the summer boarders who would stay at the Hallock Homestead, just up the hill from this beach. (Courtesy of George Schramm.)

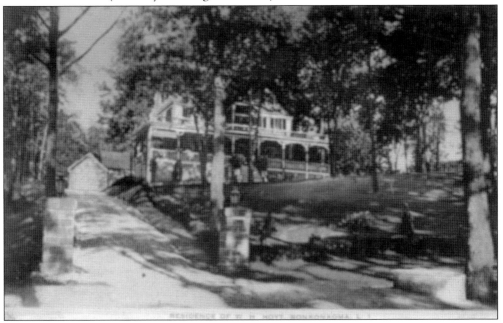

The Hoyt family was one of the early wealthy families in Lake Ronkonkoma. They had a large beautiful home built overlooking Pond Road in the 1870s. They built a changing house and a small wooden walkway and dock on the beach in front of the house, in the area known as Hoyt's Landing. The Hoyt family home still exists today and is now the home of the local Veterans of Foreign Wars (VFW) post.

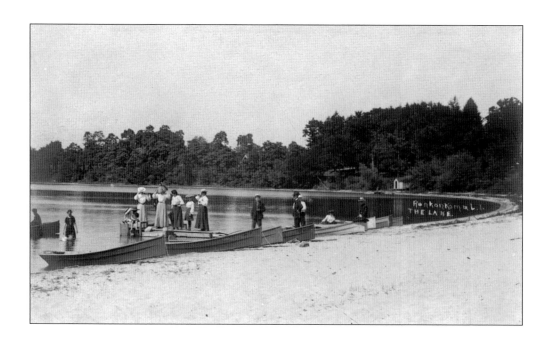

These two postcard images reveal the changes starting to occur at Young's Cove in the early 1900s. The image above is of Young's Cove around 1906, when the area is largely undeveloped. Fitz-Greene Hallock leased the beach rights for his summer borders at this time. Below is Hoyt's Landing and the small walkway and dock that was built by the Hoyt family on the Indian Hill Beach. Around this time, the Hoyt home across the street was turned into the Indian Hill Hotel.

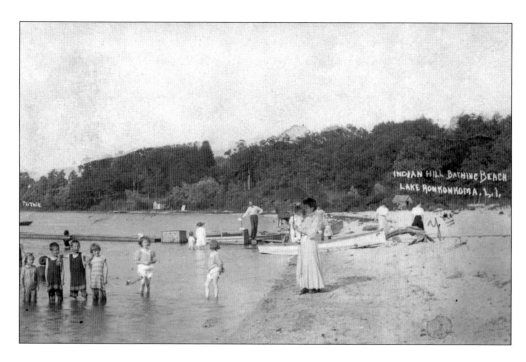

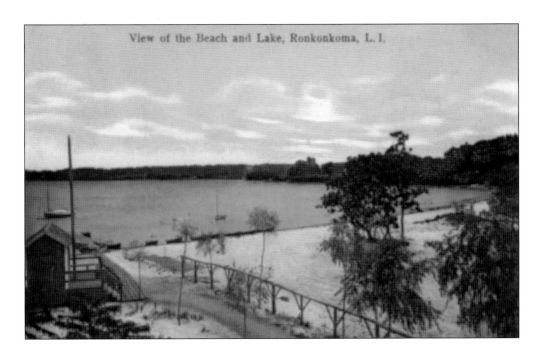

View of the Beach and Lake, Ronkonkoma, L. I.

Indian Hill Beach was a popular spot for local residents to swim. The image above shows the changing rooms built by the Indian Hill Hotel owners as well as the rowboats lined up for guest use. Below is the same beach almost a decade later. Just out of view to the left is the Indian Hill Tavern. The first lake-tour boat is also visible in the center of the photograph.

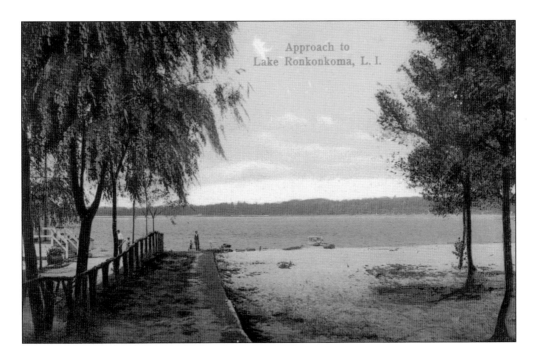

Approach to Lake Ronkonkoma, L. I.

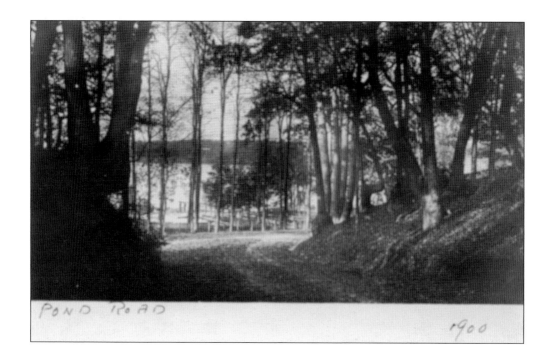

Pictured here is Lake Terrace Road at its intersection with Pond Road. The image above, from about 1900, shows the Hoyt's Landing Beach and its changing room, which can be seen through the trees on the left side of the photograph. In the 1909 postcard below, the Indian Hill Tavern can be seen on the edge of Indian Hill Beach.

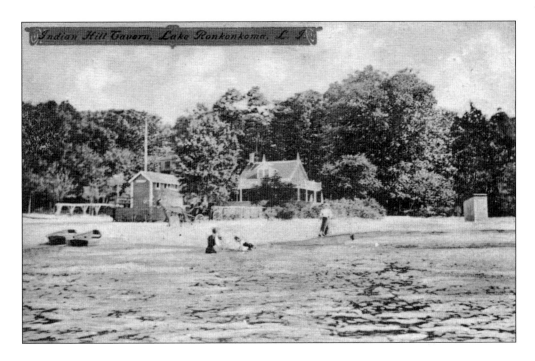

This page features views of the Indian Hill Tavern, or Hoyt's Tavern, as some local people called it. The Hoyt family built the tavern in 1907. The beautiful 1908 postcard above provides a view of Indian Hill Beach and Tavern as viewed from a boat on the lake. The 1915 postdated card below shows the American flag that was draped across Pond Road in front of the tavern during World War I. (Above, courtesy of Quinn Vollgraff and Les Hanak; below, courtesy of Helen Hethy Mulvihill.)

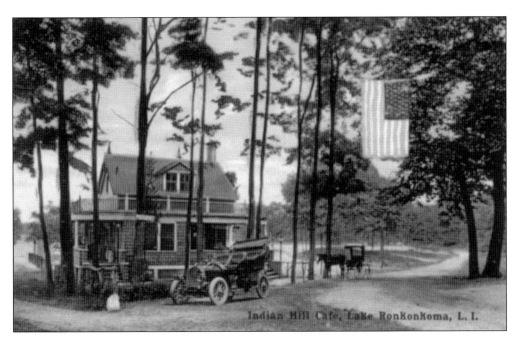

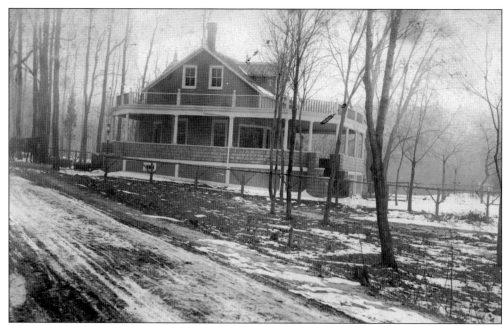

This beautiful winter scene at the Indian Hill Tavern was captured in 1910. The Hoyts changed the name to Hoyt's Casino and featured poker tables. By the end of the decade, after being owned for four years by Joseph Fiala, Herman Rugen bought the beach and café from Fiala and changed the name to Rugen's Tavern and Rugen's Beach.

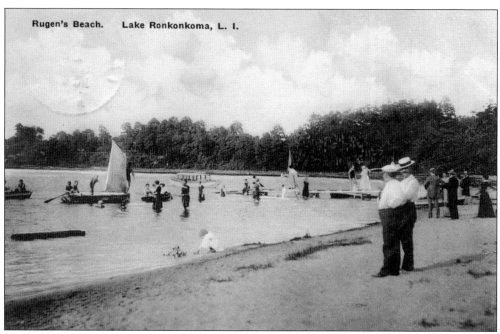

Rugen's Beach is pictured here in this 1920 postcard produced by Robert S. Feather. After purchasing the beach and tavern, Herman Rugen slowly started adding changing rooms to his beach. He later built a large gazebo–like structure above the bathhouses called Rugen's Pavilion and changed the tavern's name to Lake Shore Inn.

Casino + Hotel Gables 1891

By the 1880s, wealthy tourists from New York City who came to Lake Ronkonkoma for vacation were able to stay at the Lake Front Hotel, situated on five acres of land overlooking Lake Ronkonkoma. The hotel featured a casino, ball fields, and three cottages, one with 11 rooms, one with 14 rooms, and a more luxurious one called "The Lodge." Pictured above in the wintertime are the main building, which was called the Gables, and the Casino to its right. The postcard below captures a happy summer scene outside the Gables.

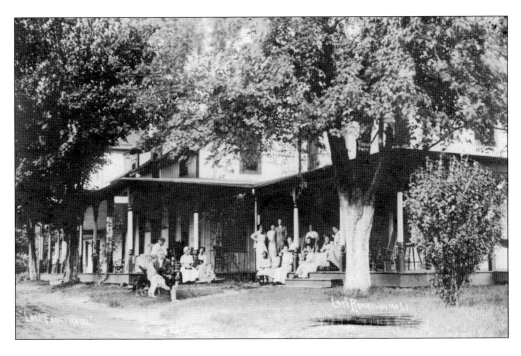

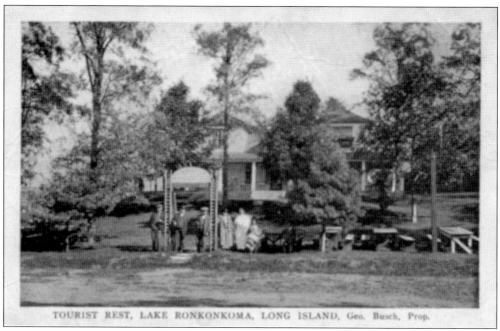

TOURIST REST, LAKE RONKONKOMA, LONG ISLAND, Geo. Busch, Prop.

Pictured here in 1910 is the Tourist Rest, on Pond Road. The Tourist Rest was located just north of the Lake Front Hotel and catered to the same wealthy clientele. Owner George Busch kept expanding his operation and built a restaurant on the beach across the street. The original tourist rest building survives today as a catering hall named Windows on the Lake.

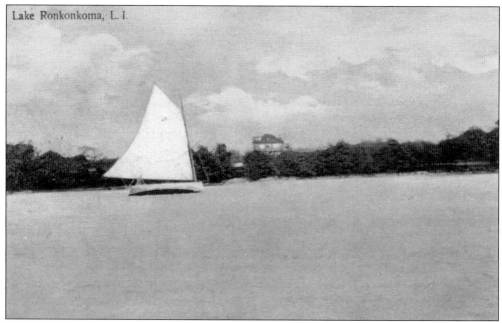

Lake Ronkonkoma, L. I.

This 1908 postcard, manufactured in Germany, shows a sailboat gliding across the lake. The Lake Front Hotel can be seen above the tree line on the shore. (Courtesy of George Schramm.)

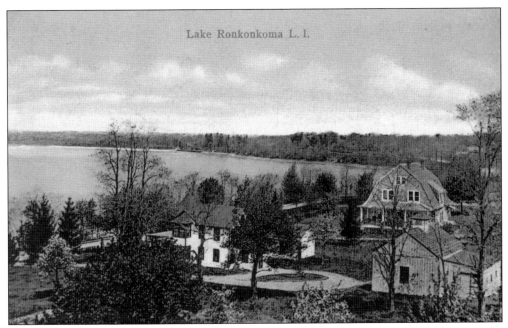

Lake Ronkonkoma L. I.

This 1914 postcard photograph was taken by Smithtown photographer Robert S. Feather from the roof of the Lake Front Hotel. On the distant shoreline in the center of the image are the changing rooms and beachfront wall of Martin Metzner's Lake Towers summer home complex.

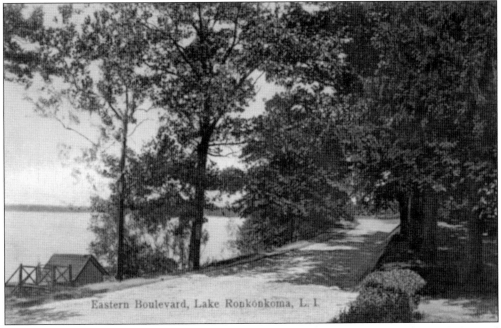

Eastern Boulevard, Lake Ronkonkoma, L. I.

Pond Road is pictured here just south of the Lake Front Hotel complex, around 1914. The road had not yet been paved at this time. Many changes have taken place at Lake Ronkonkoma over the last century, but this view looks very similar today.

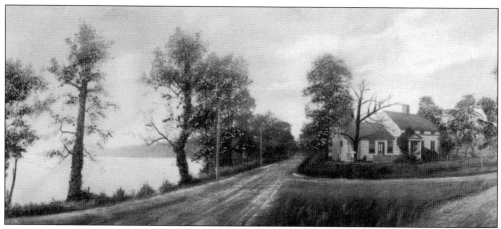

This printed-matter card postmarked March 9, 1900, looks north along Pond Road. The Amzie Newton house, built in 1780 by Caleb Newton, is on the right. It was the first house built along the shore of the lake and used as a meetinghouse by Methodists until 1834. The road in front of the house is the original route of Portion Road, which was later named Farm to Market Road. (Courtesy of Quinn Vollgraff and Les Hanak.)

This rare 1907 postcard features a photograph taken on the north shore of the lake. Pond Road is visible on the distant shoreline, and from left to right are Amzie Newton's house, the Joseph Weber house, and the Lake Front Hotel complex. The fallen trees in the foreground are a testament to the dramatic rise and fall of the lake due to changes in the water table. (Courtesy of George Schramm.)

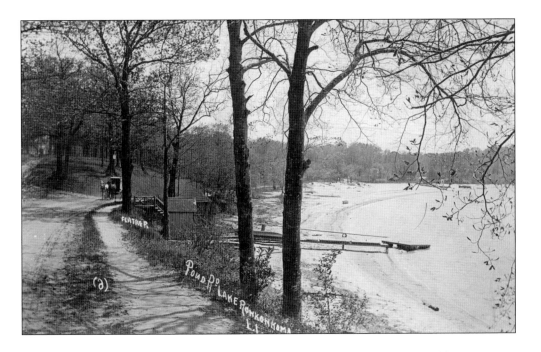

These two images of Pond Road looking south show the road in different seasons. The photograph above, taken in the off-season, features the D.J. O'Connor farm on the extreme left. The dock and outbuilding can be seen in the center. Far in the distance, the Indian Hill Beach, formerly Hoyts Landing, can be seen on the lakeshore. The image below captures approximately the same view in the summer of 1908. Note the walking path alongside the road.

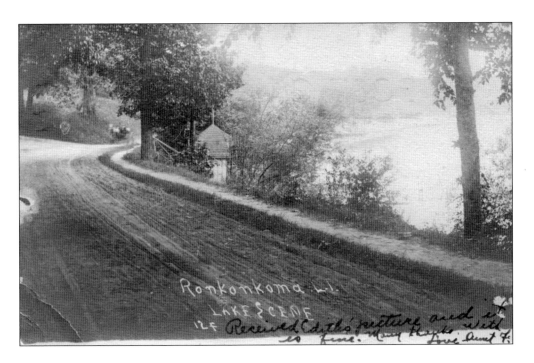

This finely produced German hand-colored postcard was created from a Robert S. Feather photograph. As well as creating his own local postcards, Feather sold images to German printing companies such as the H.O. Korten Company, which produced this image. This summer scene was taken along Portion Road looking southeast, at the Pond Road shoreline.

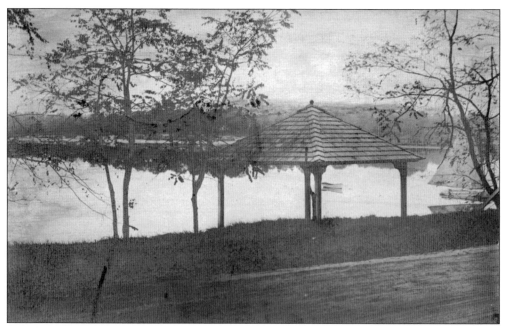

This wonderful image is postmarked December 24, 1908. It was sent as a Christmas greeting from the Warner family to the Heilman brothers at their butcher shop on Seventeenth Street in New York City. The Warners and the Heilmans were neighbors on Portion Road. George Warner added a three word caption at the bottom back corner of this card that says, "A smoky sunset."

LAKE RONKONKOMA FROM KING PLACE 1908

This Christmas postcard, dated December 24, 1908, was sent from the Warner family to Helen Finlay, another neighbor. This image is a great early view of the northeast corner of the lake, including the Joseph Weber House, the McGee residence, and the Lake Front Hotel complex.

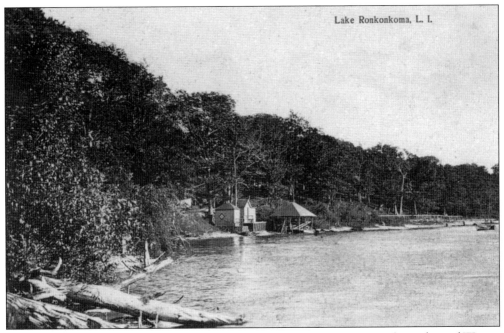

Lake Ronkonkoma, L. I.

This early image of the northeast corner of the lake features the area where the Finlay and Warner families lived. The lake shoreline is at a relatively high level, and the boathouse pictured here belonged to the Finlay family. This popular photograph was used on various Lake Ronkonkoma postcards in the first decade of the 1900s.

This Robert S. Feather–produced photographic postcard is a great example of the rural character of the lake in the late 1800s and early 1900s. It is postmarked September 12, 1913, and addressed to future Newton's garage owner Sumner Newton.

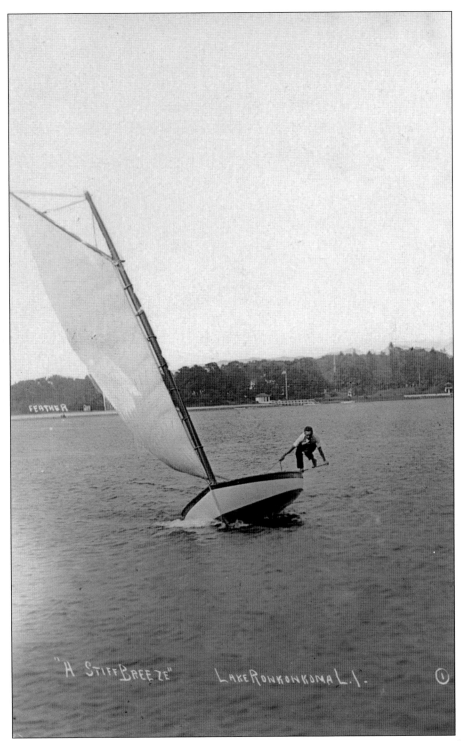

This 1912 image was also produced by Robert S. Feather. Titled *A Stiff Breeze*, it is a striking example of just how windy Lake Ronkonkoma can become. The Martin Metzner family beachfront property can be seen in the background above the boater.

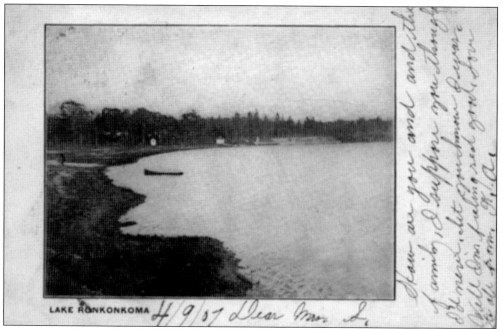

This private mailing card offers a sweeping view of the north side of the lake looking east, with the inlet to the left. To the center and the right is the Martin Metzner family beachfront property. (Courtesy of George Schramm.)

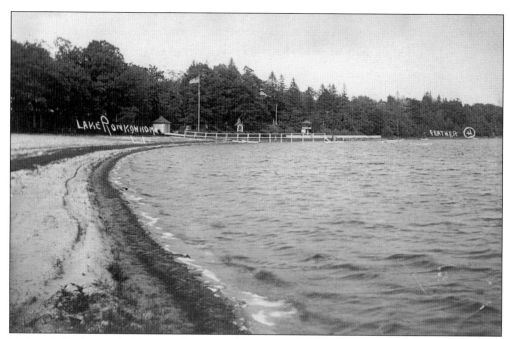

Robert S. Feather took this tranquil image of the Metzner family property looking east, including their new boat dock. The level of the lake is on the decline, as evidenced by the marks on the shoreline.

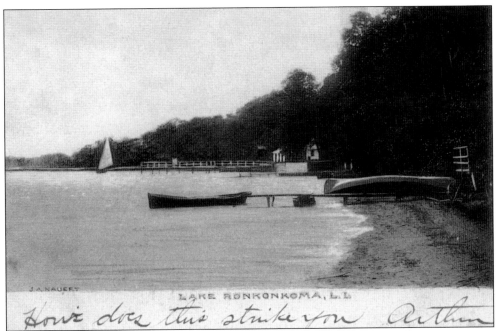

This 1907 postcard features a view of the Metzner property looking west. Both Martin Metzner and his partner Nicholas Young became millionaires while operating their rag business in Long Island City. They designed and sold a superior burlap bag for potatoes and sugar. Metzner and Young both bought hundreds of acres of property and moved to Lake Ronkonkoma after Metzner discovered it while exploring Long Island.

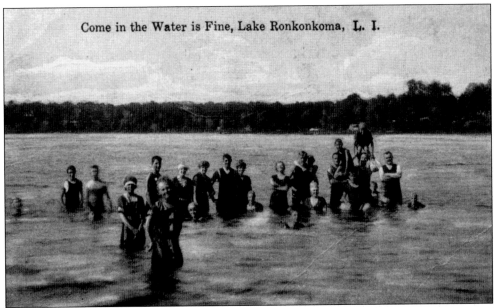

Pictured here is a typical early-1900s group enjoying a swim at the lake. The growing popularity of Ronkonkoma in the Pines was bringing more people to its shores every summer. Note the varied bathing costumes of the era.

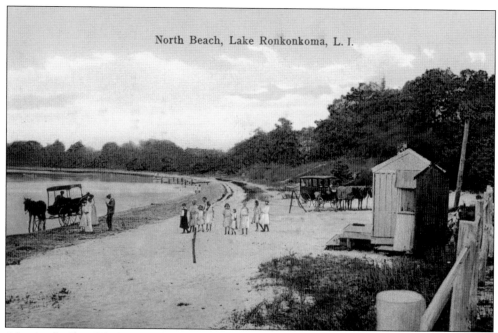

North Beach, Lake Ronkonkoma, L. I.

After producing a black-and-white postcard of this photograph, Robert S. Feather sold the image to the German printing company H.O. Kurten, which produced this hand-colored version. It shows a group of girls at a Metzner gathering enjoying the beach. Evidence of a dramatic fall in the level of the lake can be seen along the shoreline.

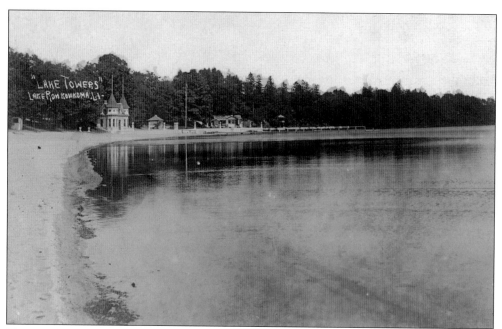

Two new buildings can be seen in this postcard from about 1914. The Metzner beachfront now includes the castle-like guest house toward the left and a bungalow to the right. (Courtesy of Quinn Vollgraff and Les Hanak.)

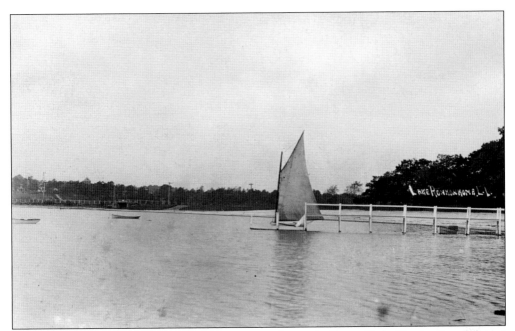

The Metzner family built a huge summer home on the north shore of Lake Ronkonkoma named Lake Towers. This 1914 image shows the Metzner sailboat moored at the end of their private dock. Farther to the left along the shore is the new 16-foot bridge over the inlet and the Van Osterman family house, which can be seen poking over the tree line. (Courtesy of George Schramm.)

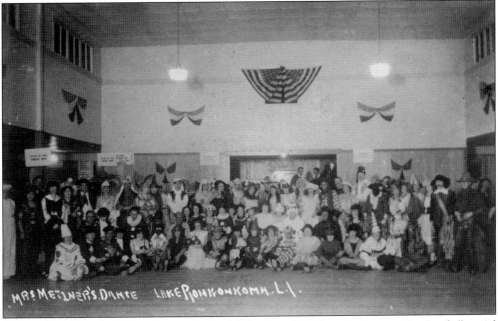

The Metzner family did not live an isolated life of wealth. They had many friends of all social classes and held huge parties and gatherings throughout the year. This is the crowd at a masquerade ball that Johanna Metzner held at the gymnasium of the nearby Winwood School, which was located just down the road from the Metzners' winter home on Parsnip Pond Road.

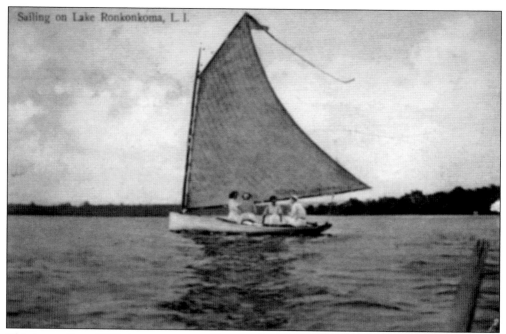

This image from 1908 shows a group sailing on the lake. By this year, a few hundred New York City residents, as well as Long Islanders, were utilizing this beautiful lake and its surroundings for vacations and day outings.

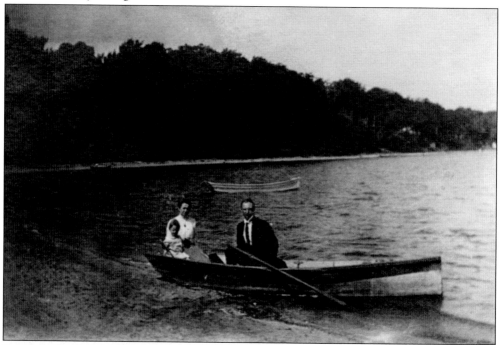

Postcards like this 1910 photographic card tantalized people from other areas with the beauty and serenity of the lake. The family shown here is enjoying a peaceful outing in the country, a contrast to the hectic, crazy scene at beach areas like Coney Island in New York City. (Courtesy Quinn Vollgraff and Les Hanak.)

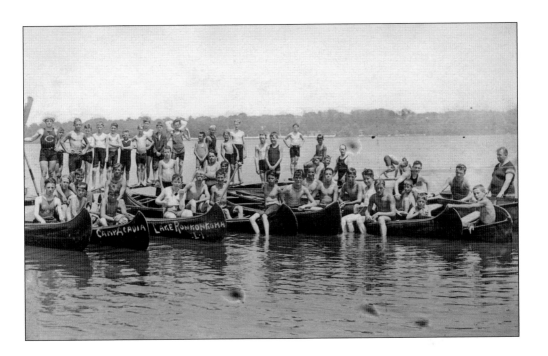

These two postcards offer views of Camp Arcadia, which was located on the west side of the lake. When William K. Vanderbilt III bought and sold land around Lake Ronkonkoma, in the course of building the Long Island Motor Parkway, he graciously allowed groups of impoverished children from various New York City churches to use some of his lakefront land for summer camps. (Both, courtesy of Quinn Vollgraff and Les Hanak.)

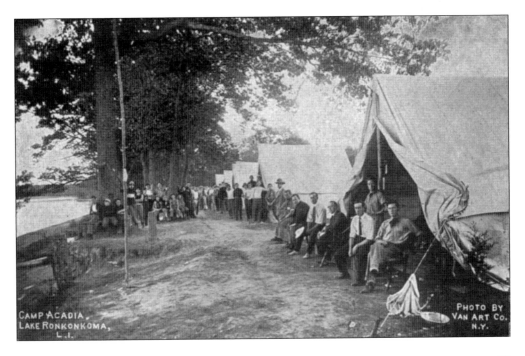

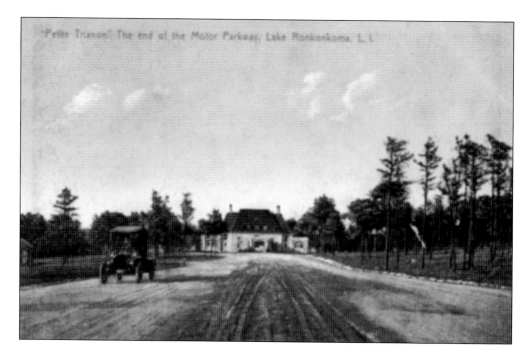

William K. Vanderbilt III began building the Long Island Motor Parkway, the first limited-access toll road for automobiles, in 1906. The parkway ran from the borough of Queens in New York City east to the edge of Lake Ronkonkoma. When the road was completed in 1911, Vanderbilt built the Petit Trianon, a five-star restaurant with two lounges and 30 guest rooms, on the shoreline of the lake. The image above shows the main drive from the Long Island Motor Parkway in 1911. Below is the building as seen from the shore of the lake. At this time, few understood the profound impact the Long Island Motor Parkway would have on the future of Lake Ronkonkoma.

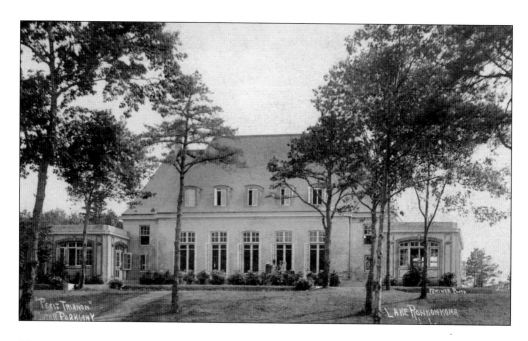

Two

LIFE AT THE BEACH

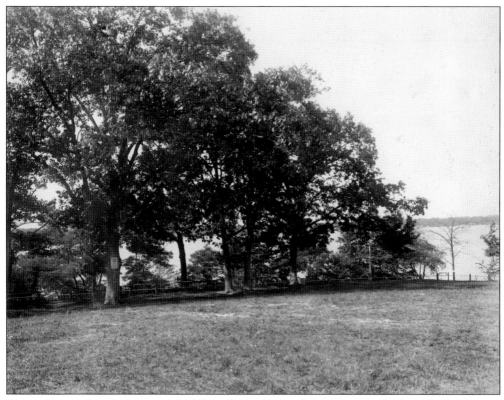

Pictured here is the picnic area on the hilltop field at Raynor's Lakeview Beach. Crowds of swimmers would show up daily to enjoy a summer day at this newly created beach resort. The crowds encouraged George Raynor to keep improving and expanding Raynor's Lakeview Beach.

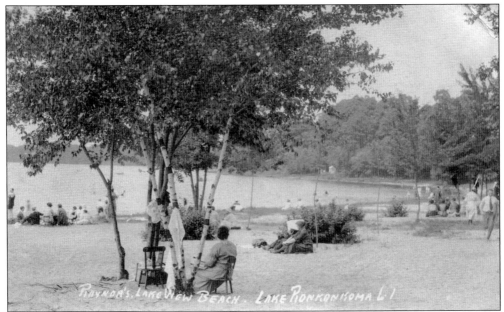

These two postcards depict Raynor's Lakeview Beach in its first years of operation. When Raynor found that a farm on a ridge overlooking the lake that he had purchased as an investment was strewn with litter, he did some investigating. Raynor discovered that the farm, formerly owned by D.J. O'Connor, was being used by scores of motorists who came to Lake Ronkonkoma via the Long Island Motor Parkway as a picnic ground and parking lot. The motorists had come to enjoy the beach below. Raynor, always the businessman, devised a plan. He began charging 50¢ for parking, turned the farmhouse into a restaurant, and built changing rooms and a refreshment stand. He called his new enterprise Raynor's Lakeview Beach, and it was an instant success. (Both, courtesy of Quinn Vollgraff and Les Hanak.)

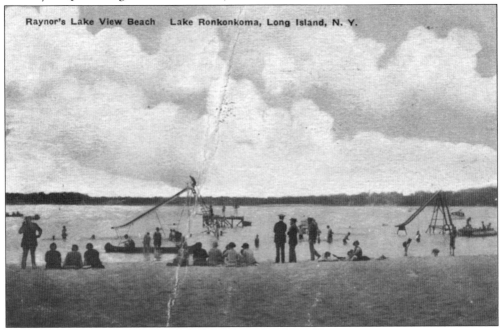

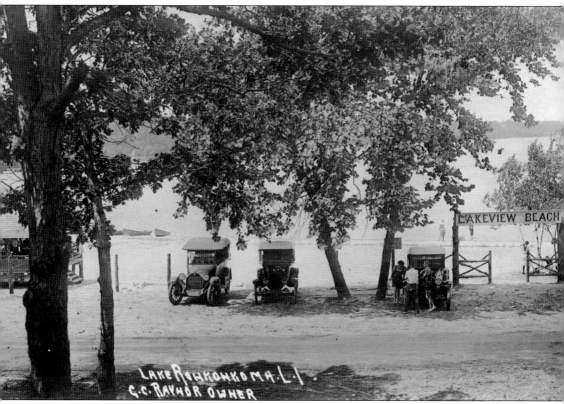

This wonderful postcard shows Raynor's Lakeview Beach as it looked when viewed from the picnic area on the top of the hill. The first pavilion built on the beach can be seen to the far left, in its original form.

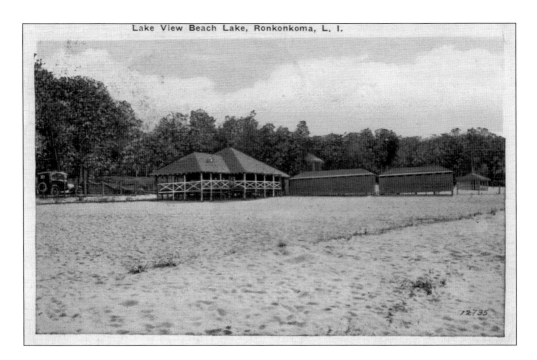

These two postcards are of the first pavilion, which was built on Raynor's Lakeview Beach around 1923. Above is the pavilion, which contained picnic tables on the left and two buildings of changing rooms to the right. Behind the fence in the far right, the original Jean's Green Pavilion is still under construction. Pictured below is the same beach pavilion after it was expanded for the second time since its initial construction. The crowds grew larger every year. (Above, courtesy of Quinn Vollgraff and Les Hanak.)

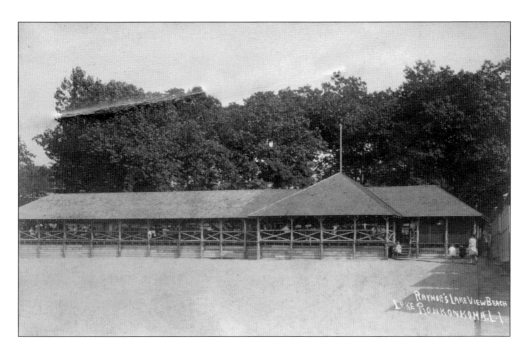

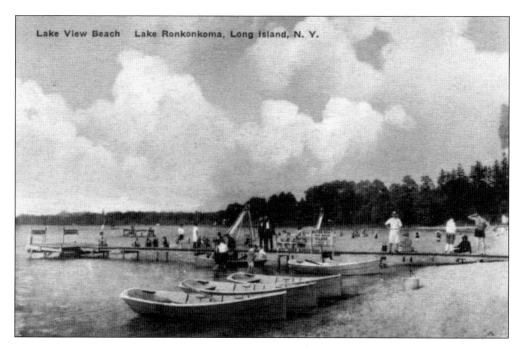

Lake View Beach Lake Ronkonkoma, Long Island, N. Y.

These two wonderful postcards show views of the boat dock at Raynor's Lakeview Beach. A boat named *Dark Cloud* conducted tours of the lake complete with a tour guide. The price for a ride was 25¢ for adults and 12¢ for children. Above are rowboats available for rent at the beach. The photograph below, taken a few years later, captures a tour boat leaving the dock. Note the Olympia Pavilion under construction in the background. (Above, courtesy of Quinn Vollgraff and Les Hanak.)

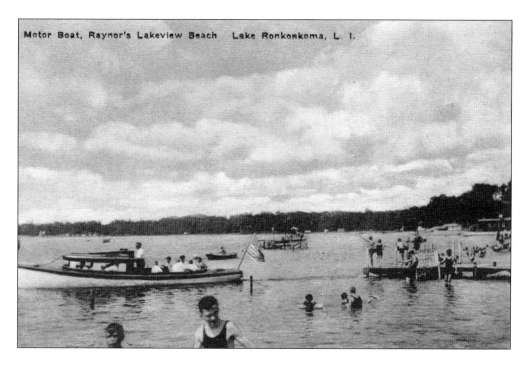

Motor Boat, Raynor's Lakeview Beach Lake Ronkonkoma, L. I.

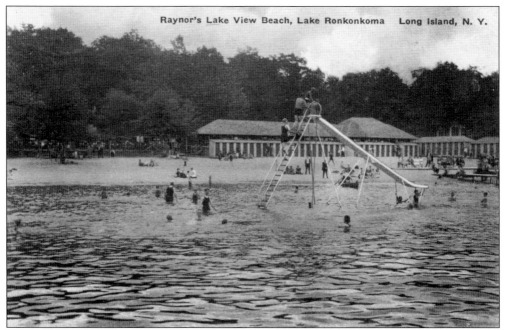

Public demand caused Raynor to make more changes to his Lakeview Beach. Shown here are the addition changing rooms built in front of the Pavilion on the beach. On the right is the wooden walkway to the beach. (Courtesy of Quinn Vollgraff and Les Hanak.)

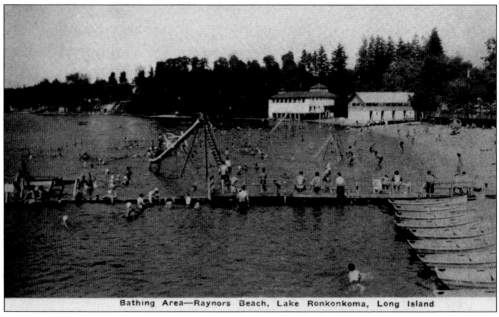

As George Raynor kept expanding his beach business, local Realtor Paula Browne was also building pavilions on the beach. This photo shows the Mayfair Pavilion to the left of George's new beach front pavilion; in the rear to the left the early phases of construction of the Olympia Pavilion can be seen.

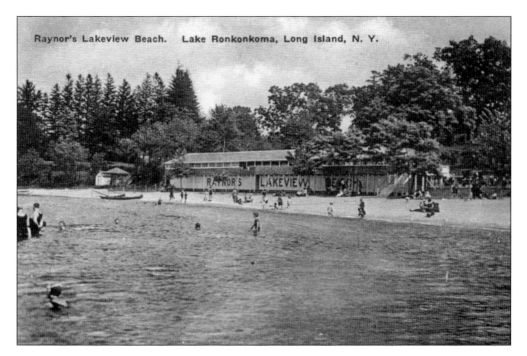

Raynor's Lakeview Beach. Lake Ronkonkoma, Long Island, N. Y.

In 1923, George C. Raynor built a new pavilion with changing rooms at the northern edge of the Raynor's Lakeview Beach property near the Mayfair Pavilion. Due to high demand, he soon enlarged the pavilion and moved it to a more advantageous position along Pond Road. The image above shows the completed pavilion at the north end of Raynor's Beach. The image below, postmarked August 30, 1924, shows the southern edge of the new pavilion. In the background toward the right, the restaurant on the hilltop portion of Raynor's can be seen through the trees. (Below, courtesy of Janet Rischbieter.)

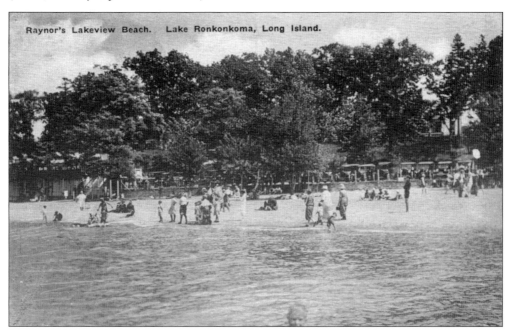

Raynor's Lakeview Beach. Lake Ronkonkoma, Long Island.

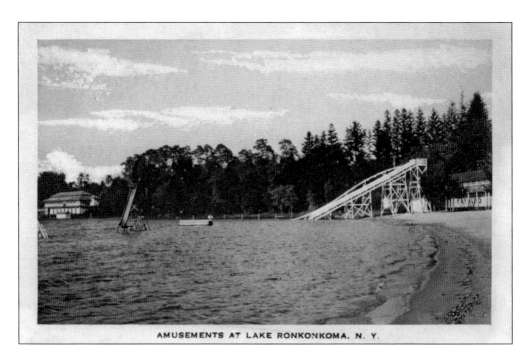

AMUSEMENTS AT LAKE RONKONKOMA, N. Y.

The next new attraction to be built at Raynor's Lakeview Beach was the toboggan slide, constructed at the north end of the Raynor complex in front of the new pavilion building. Guests would ride a wooden sled down the track at high speeds, and upon reaching the water, the sled and rider would skim out along the water. Note the Olympia pavilion at the far left of the photograph. The postcard below shows a typical summer crowd enjoying the attractions at Raynor's Lakeview Beach in the late 1920s. (Below, courtesy of Mary Klein.)

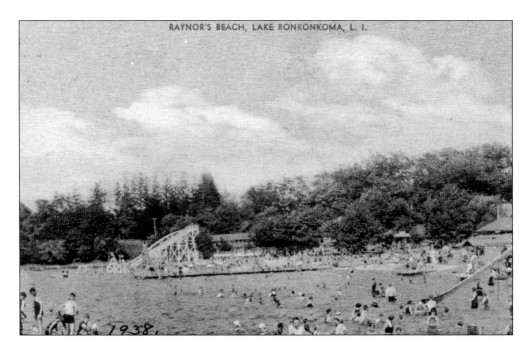

RAYNOR'S BEACH, LAKE RONKONKOMA, L. I.

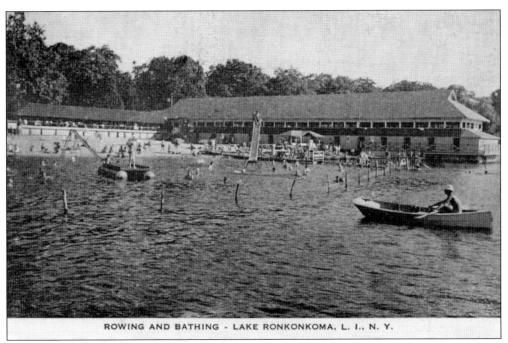

ROWING AND BATHING - LAKE RONKONKOMA, L. I., N. Y.

Next, George Raynor added a new beachfront pavilion to the ever-growing Raynor's Lakeveiw Beach complex. The pavilion measured 200 feet in length, and it became the largest public room available in town. The new pavilion could now hold graduations and many other large functions. Note the safety fence built in the water around the beach. (Courtesy of Quinn Vollgraff and Les Hanak.)

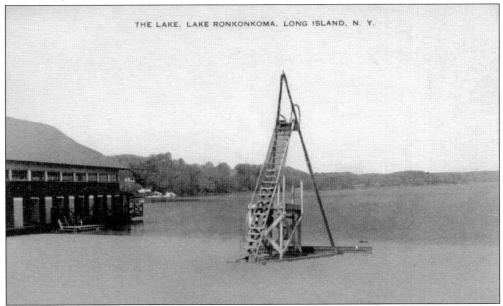

THE LAKE, LAKE RONKONKOMA, LONG ISLAND, N. Y.

During the winter, the floating docks and water slides at various pavilions would be removed from the water and stored on the beach. Raynor's slides are shown in this photograph. Just behind the pavilion, the Light House Beach can be seen in the background. By the late 1930s, the name of the beach was shortened to Raynor's Beach.

41

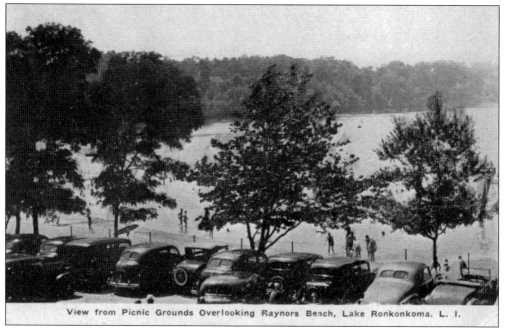

View from Picnic Grounds Overlooking Raynors Beach, Lake Ronkonkoma. L. I.

Raynor's Beach is pictured here in 1939 from the picnic area at the top of the hill. Raynor's was known as a beach that catered to families with children. George and his two sons, G. Stuart and Renwick, operated the Raynor's Beach empire for well over 40 years. (Courtesy of Quinn Vollgraff and Les Hanak.)

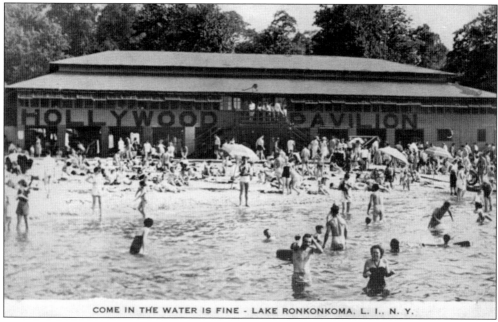

COME IN THE WATER IS FINE - LAKE RONKONKOMA. L. I., N. Y.

The Hollywood Pavilion, which was located at the southwest corner of the lake, is pictured here around 1950. It was built by Paula Browne in the mid-1920s and later sold to Charles Kruger. Kruger and his extended family operated Hollywood Beach for well over three decades. (Courtesy of Quinn Vollgraff and Les Hanak.)

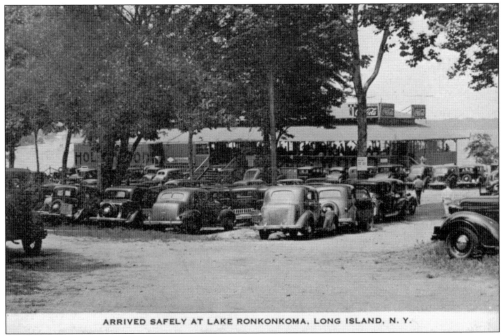

ARRIVED SAFELY AT LAKE RONKONKOMA, LONG ISLAND, N. Y.

The Hollywood Pavilion is pictured here in 1947 from one of the two parking areas behind the building. To the left is the office and living quarters. Charles Kruger's son and his family would leave their Queens home in the summer and live in the pavilion, and they would stay for the season and assist in the operating of the beach. (Courtesy of Quinn Vollgraff and Les Hanak.)

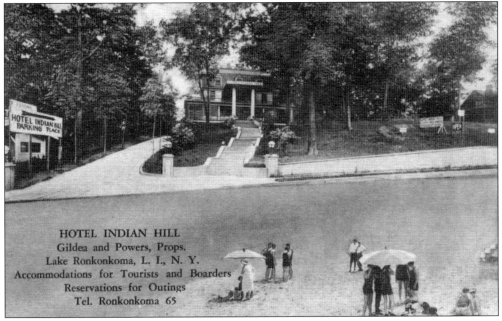

HOTEL INDIAN HILL
Gildea and Powers, Props.
Lake Ronkonkoma, L. I., N. Y.
Accommodations for Tourists and Boarders
Reservations for Outings
Tel. Ronkonkoma 65

By the time this postcard was postmarked on September 8, 1922, the Hotel Indian Hill, located on Pond Road opposite the Hollywood Pavilion, had gained a reputation as an upscale hotel. It operated for well over three decades. Famous guests such as Jackie Gleason and Ronald Reagan were known to frequent this hotel.

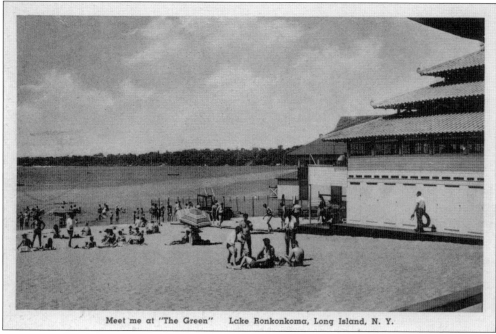

Meet me at "The Green" Lake Ronkonkoma, Long Island, N. Y.

Inspired by the immediate success of Raynor's Lakeview Beach, Paula Browne, a local real–estate investor, started building beach pavilions on Lake Ronkonkoma. One of her first efforts was the Green Pavilion, a small building built next to Raynor's Beach. After a year of successful operation, she sold it for a handsome profit. The Green Pavilion burned down years later, but the owners then built a much larger grand pavilion to replace it. In the image above, the Raynor's Beach Pavilion can be seen jutting out from behind the "Green." Some years later, a canopy-covered boardwalk was built (shown below) along the parking area between the "Green" and Rugen's Tavern. (Below, courtesy of Quinn Vollgraff and Les Hanak.)

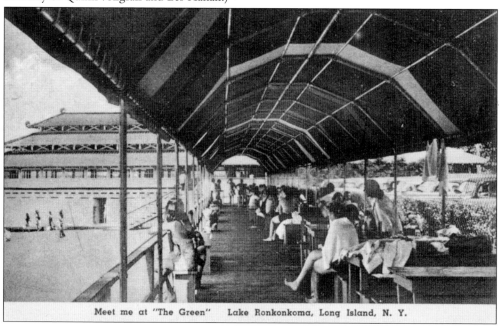

Meet me at "The Green" Lake Ronkonkoma, Long Island, N. Y.

When Herman Rugen bought Hoyt's Tavern and the beach in front of it, he changed the name to Rugen's Tavern and Rugen's Beach. Rugen kept expanding his beach facilities, adding changing rooms and an elevated gazebo above them. He eventually changed the name of the tavern to the Lake Shore Inn. It featured guest rooms as well as a fine restaurant. Above is a photograph of the Lake Shore Inn from 1940, and below is a business card from the establishment. (Both, courtesy of Quinn Vollgraff and Les Hanak.)

BOATS TO RENT FOR FISHING TEL. RON. 8550

LAKE SHORE INN

H. RUGEN, PROP.

POND ROAD, LAKE RONKONKOMA

Dinners and All Kinds of Luncheons *Outings Accommodated*

BATH HOUSES TO HIRE **BATHING SUITS TO RENT**

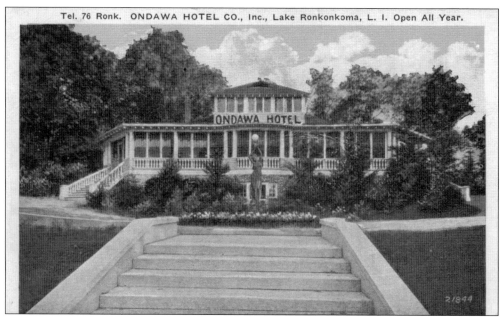

The Ondawa Hotel was built in 1888 as the private home of Adolph Wiechers, a wealthy man who moved here from Germany with the intention of investing in real estate. His daughter, Paula Browne, inherited the home as well as her father's business sense. Browne turned the house into the Ondawa Hotel and then sold it at a handsome profit; this was the start of her lucrative real-estate career. The hotel operated successfully until its destruction by fire in 1958. (Courtesy of Quinn Vollgraff and Les Hanak.)

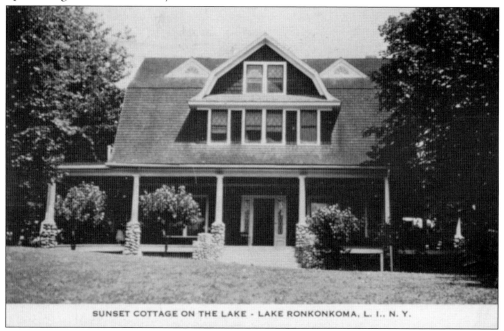

SUNSET COTTAGE ON THE LAKE - LAKE RONKONKOMA, L. I., N. Y.

The McGee house, a longtime family home on Pond Road, became Sunset Cottage, an early version of a bed-and-breakfast. Its location on Pond Road made it a popular place to rent a quiet room near the busy beach pavilions. (Courtesy of Quinn Vollgraff and Les Hanak.)

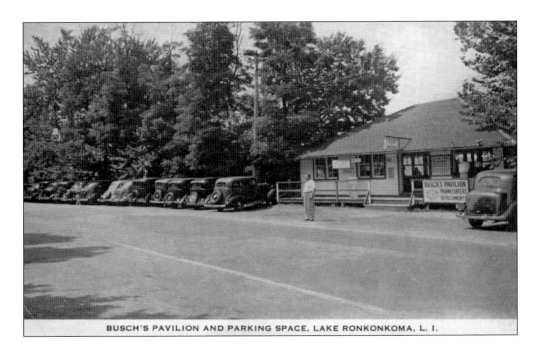

BUSCH'S PAVILION AND PARKING SPACE, LAKE RONKONKOMA, L. I.

These postcards offer two views of Busch's Beach on Pond Road. The image above shows Busch's Pavilion, a popular stop for motorists along Pond Road. This pavilion had a reputation for great food and was often crowded. Pictured below, Busch's Beach offered changing rooms, showers, a shaded picnic area, and a playground for children. (Both, courtesy of Quinn Vollgraff and Les Hanak.)

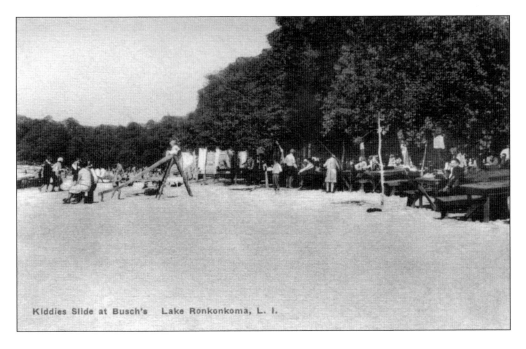

Kiddies Slide at Busch's Lake Ronkonkoma, L. I.

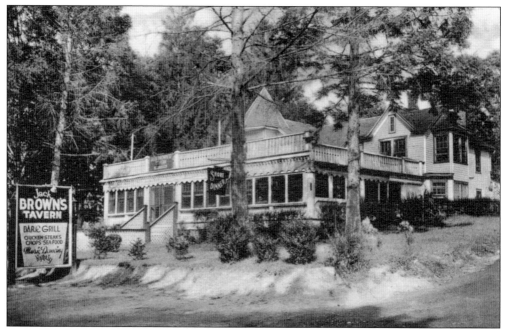

Jack Brown's Tavern was an extremely popular bar and grill on Pond Road, owned by Paula Browne but leased by Jack Brown. The tavern featured good food, liquor, entertainment, and dancing. The bar operated successfully through Prohibition, and many generations of Ronkonkoma residents enjoyed themselves here. (Courtesy of Quinn Vollgraff and Les Hanak.)

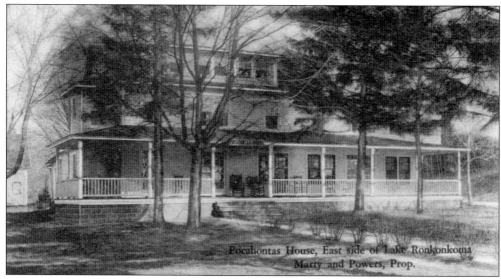

Pocahontas House was one of the many hotels built along Pond Road to serve the Lake Ronkonkoma tourist trade. Hotels like this offered a comfortable quiet place to sleep and relax after a day at the crowded beaches. This photograph was taken by the well-known photographer E.E. Brown, of Patchogue, New York. (Courtesy of Quinn Vollgraff and Les Hanak.)

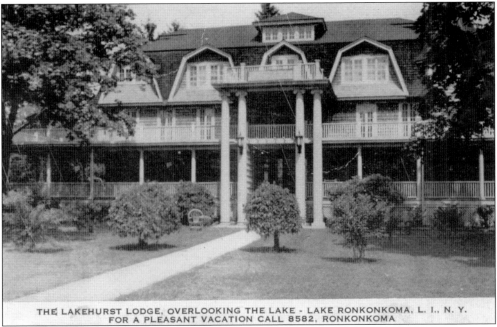

THE LAKEHURST LODGE, OVERLOOKING THE LAKE - LAKE RONKONKOMA, L. I., N. Y.
FOR A PLEASANT VACATION CALL 8582, RONKONKOMA

The Lakehurst Lodge, located on Pond Road, was one of the many fine hotels that served visitors to Lake Ronkonkoma. The lodge was originally built as a beautiful two-story private home by retired New York City police captain Frank Rohrig. He soon took a job with Islip town as a Lake Ronkonkoma boat patrol officer. He lived in the home until his death in 1943. New owner Louis Feiler added a third floor and started the Lakehurst Lodge. The Lakehurst building survives today as part of the Phoenix House Rehabilitation Center.

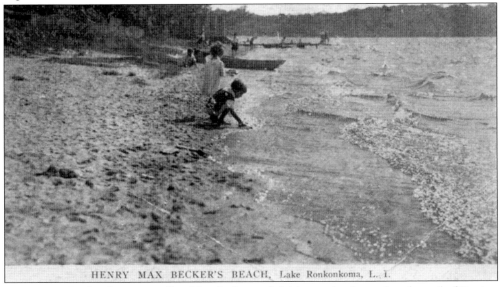

HENRY MAX BECKER'S BEACH, Lake Ronkonkoma, L. I.

Henry Max Becker, known to all as Max, had a small fishing station located at the end of Portion Road in the late 1800s and early 1900s. Visitors to the nearby Lake Front Hotel or the Tourist Inn could go to Max for anything they needed for fishing, from rowboats to lessons. Pictured here in this early rare photo are Becker's Beach and fishing dock located near the northeast corner of the lake.

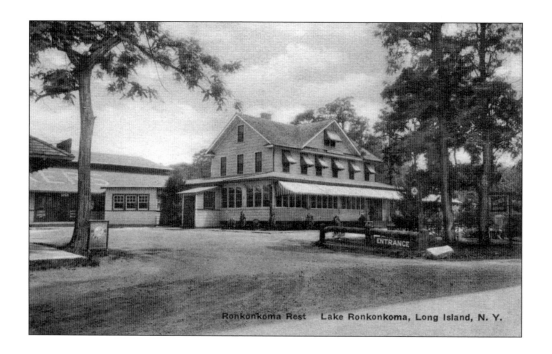

Ronkonkoma Rest Lake Ronkonkoma, Long Island, N. Y.

In the 1920s, landowners around the lake took advantage of the increasing tourist trade and started to build beach facilities. The Becker brothers built a deluxe hotel, pictured here, and beach complex. The hotel, named the Ronkonkoma Rest, featured a restaurant and bowling alley. (Both, courtesy of Quinn Vollgraff and Les Hanak.)

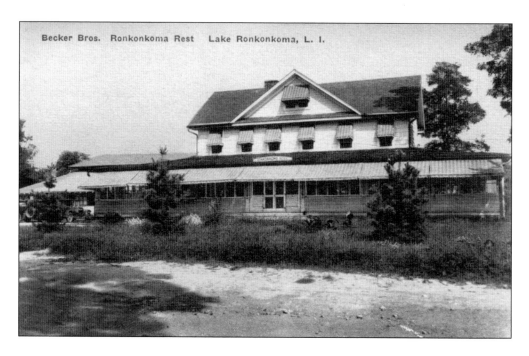

Becker Bros. Ronkonkoma Rest Lake Ronkonkoma, L. I.

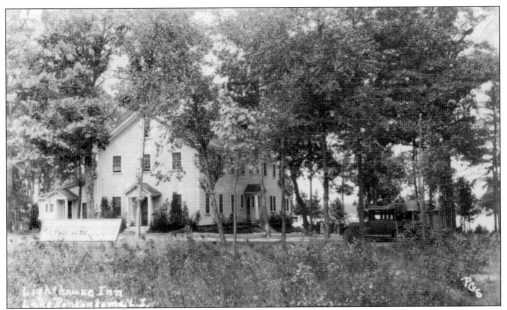

Lighthouse Inn was a luxurious lodging built along the southern shore of Lake Ronkonkoma around 1914. The inn, which had 17 guest rooms, was operated by W. Richert and catered to well-heeled tourists. It was a luxury-class inn with a high-quality restaurant and a bowling alley. (Courtesy of Quinn Vollgraff and Les Hanak.)

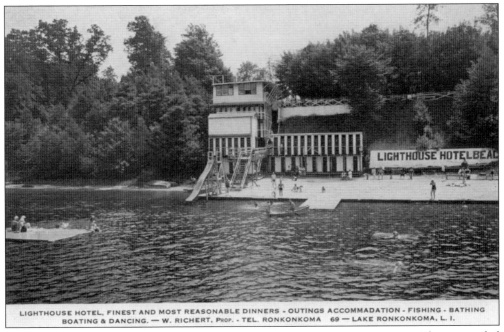

LIGHTHOUSE HOTEL, FINEST AND MOST REASONABLE DINNERS - OUTINGS ACCOMMADATION - FISHING - BATHING
BOATING & DANCING. — W. RICHERT, PROP. - TEL. RONKONKOMA 69 — LAKE RONKONKOMA, L. I.

As the tourist trade grew rapidly at Lake Ronkonkoma so did the Lighthouse Inn. Richert expanded his beachfront to cater to the ever-growing crowds. This rare early image of the Lighthouse Hotel Beach shows the floating dock, slide into the lake, early boat dock, and multilevel changing rooms. The shaded picnic grove can be seen on the hilltop. (Courtesy of Quinn Vollgraff and Les Hanak.)

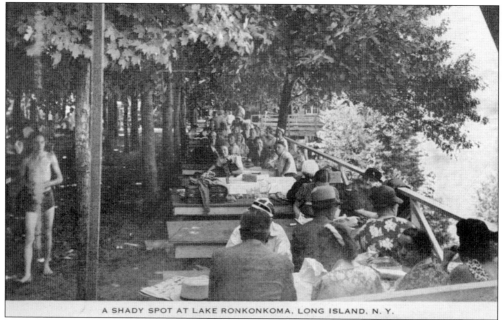

A SHADY SPOT AT LAKE RONKONKOMA, LONG ISLAND, N. Y.

In 1930, Charles and Helen Fikon bought the Lighthouse Inn and further expanded the business. The hilltop picnic area at the Lighthouse Hotel was a cool, shady grove with picnic tables that commanded an impressive view of the lake and beach below. The Fikons added a large staircase that ran from the picnic area directly to the beach, which now contained 187 bathhouses for visitors, and expanded the boat dock.

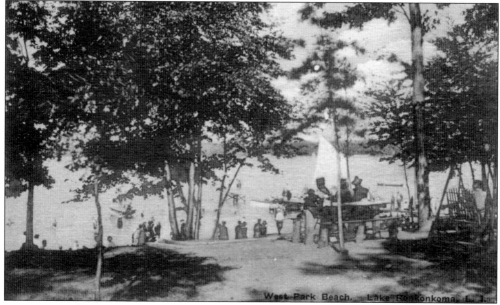

West Park Beach, Lake Ronkonkoma, L. I.

The back of this postcard from August 2, 1922, reads, "West Park Beach Lake Ronkonkoma L. I. white sandy bathing beach. Beautiful shaded groves with tables for basket parties. Canoes, boats, bathhouses, motor launch. All kinds of refreshments. Plenty of auto parking spaces. This is the place to bring your family and friends for a day's outing. Take Motor Parkway and turn to the right at the foot of the hill after leaving Ronkonkoma Lodge, 500 feet ahead is 'West Park Beach.' "

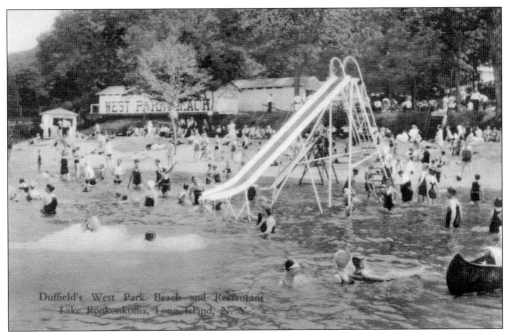

Duffield's West Park Beach and Restaurant
Lake Ronkonkoma, Long Island, N. Y.

Duffield's West Park Beach, located on the west side of Lake Ronkonkoma, first opened for business in 1921. Ray Duffield built a small pavilion and modest changing rooms, but scores of visitors made it necessary to enlarge the facilities. By 1922, a large section of bathhouses, a playground, and a picnic area were built. As the crowds grew, water slides, a water wheel, canoes, rowboats, and a motor-launch tour boat were added. Tennis courts and a huge pavilion with a barbeque shack were soon added. The image above shows a typical summer day at Duffield's, with the bathhouses located just above the beach. The image below shows the large pavilion to the north of the bathhouses.

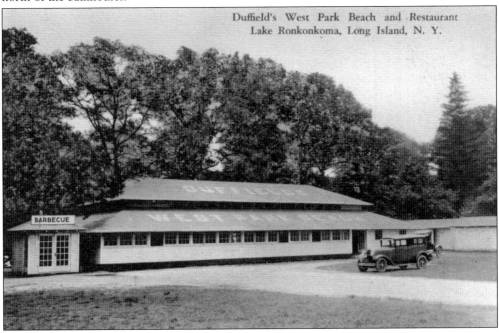

Duffield's West Park Beach and Restaurant
Lake Ronkonkoma, Long Island, N. Y.

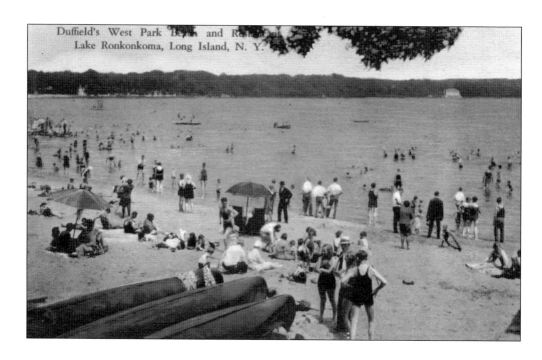

Duffield's West Park Beach was highly successful and run by many members of the Duffield family for over four decades. They specialized in hosting large outings by churches and civic groups. Large companies also held their picnics here. The Robert S. Feather–produced postcard shown above from the 1920s pictures people enjoying various activities on Duffield Beach. Note the Blue Beach Pavilion on the distant shoreline to the right. Below, children enjoy themselves on the playground located next to the beachfront changing rooms.

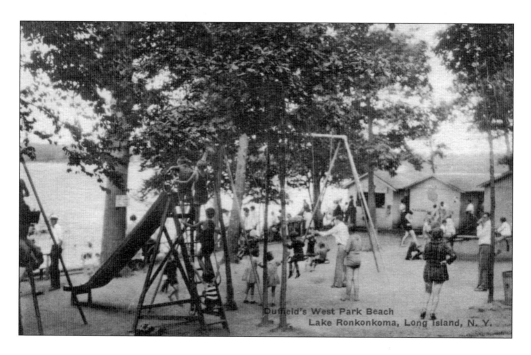

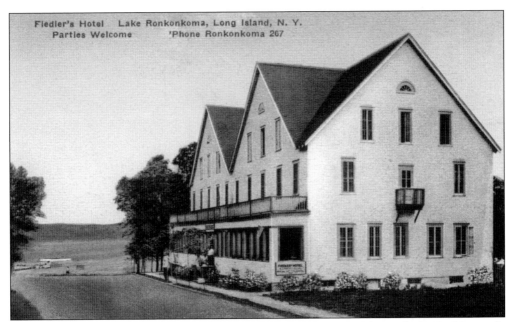

Gustave Fiedler built a 40-room hotel along the west shore of the lake at the end of Rosevale Avenue, and Fiedler's Hotel opened for business on June 1, 1927. The hotel included a large restaurant, the Munchner Brau Stube, which specialized in German food and beers. The restaurant had a large dance floor and plenty of room for an orchestra. The Steuben Society and many other local organizations held meetings and dances there.

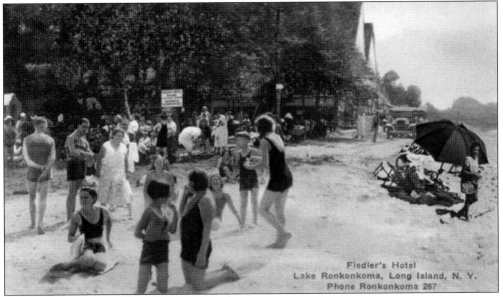

Fiedler's Hotel also had a bustling beach operation. By the time Fiedler's Hotel opened its doors in 1927, thousands were flocking to Lake Ronkonkoma to enjoy its beautiful beaches. The large shaded picnic area at Fiedler's was one of the attractions that bought families to this popular beach. (Note the Model A parked on the beach). Unfortunately, a fire on May 7, 1937, destroyed Fiedler's Hotel. After the fire, Gustave Fiedler moved to Eastport, Long Island, and opened John Ducks Eastport Hotel.

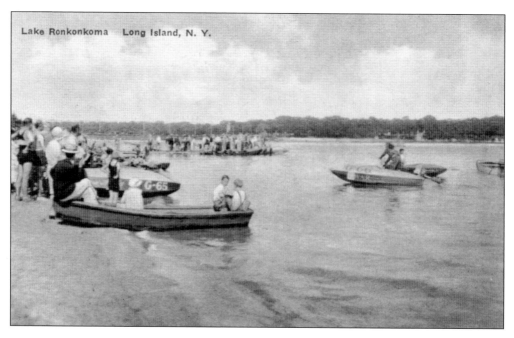

Lake Ronkonkoma Long Island, N. Y.

Jack Yerk's was one of the most popular beaches on the west shore of Lake Ronkonkoma. Yerk's Beach featured a beach pavilion, bar, shady picnic area, playground, baseball field, waterslides, and a large boat dock (shown above). Until outboard motors were banned from the lake in 1934, Yerk's was the starting point for the popular speedboat races. In 1940, Yerk's added an outdoor bowling alley. Starting in January 1941, floodlights lit the ice up for night skating on the lake. In the spring of 1941, a casino was added. The image below depicts a typical summer day at Yerk's Beach in the early 1930s.

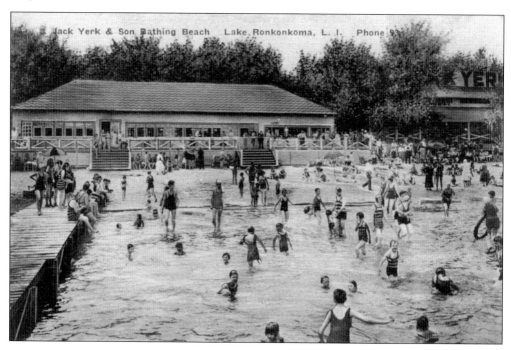

Jack Yerk & Son Bathing Beach Lake Ronkonkoma, L. I. Phone 9

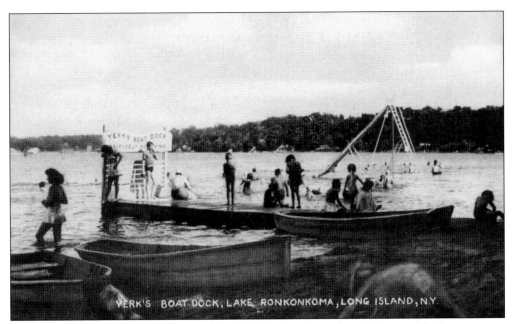

In 1934, outboard motors were banned from Lake Ronkonkoma, largely due to pollution concerns. The boat dock at Yerk's Beach was then shortened so it could be used exclusively for rowboat and canoe docking. Note the sign at the end of the dock that reads, "Positively No Diving."

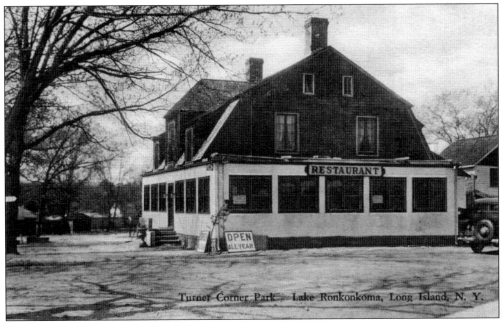

In 1924, Arthur Turner bought the estate of Dr. J. R. Wood, which was located along the northwest corner of Lake Ronkonkoma, and created Turner's Corner Park. The beautiful home on the property was renovated and turned into the Shady Rest Tavern and Restaurant. This image shows the Shady Rest after the wraparound patio was enclosed to create more indoor seating in the 1930s.

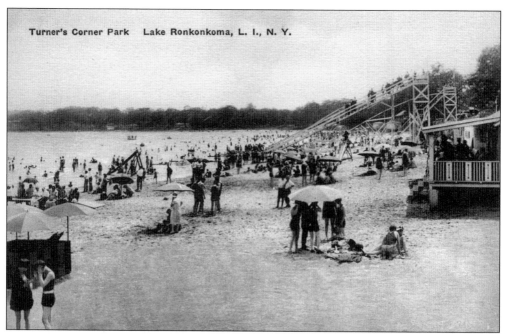

Turner's Corner Park Lake Ronkonkoma, L. I., N. Y.

Turner's Corner Park operated for over three decades, as Arthur Turner kept adding new attractions to his park every few years. On the shoreline he built a large dance hall and brought in big-name jazz bands to play there. To the east he built a large toboggan slide and a small beach pavilion to serve the many people who came to swim at Turner's.

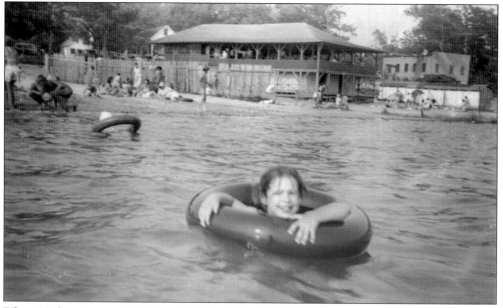

Eileen Hethy enjoys a tube ride at the Ronkonkoma Shores Beach on the north side of the Lake around 1950. Visible in the background are the Beverly Beach Pavilion and the Cedar Grove to the right.

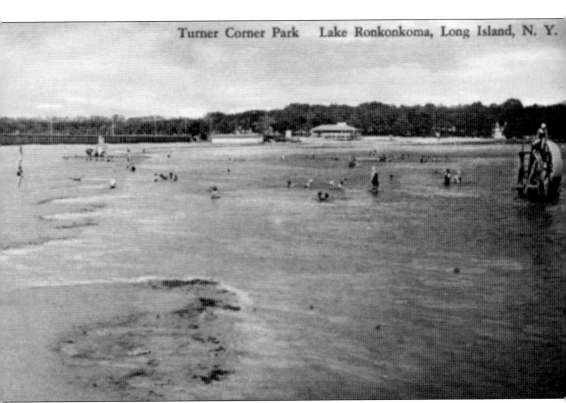

This postcard photograph was taken on the beach at Turner's Corner Park. Sitting on the distant shoreline are, from left to right, the long row of changing rooms along Shore Lane built by William and Mary Anderson for Merkel's Pavilion, the changing rooms at the Ronkonkoma Shores Beach, the Beverly Beach Pavilion, and the castle-like beach cottage on the Metzners' estate. The waterwheel to the far right is located at Turner's Corner Park Beach.

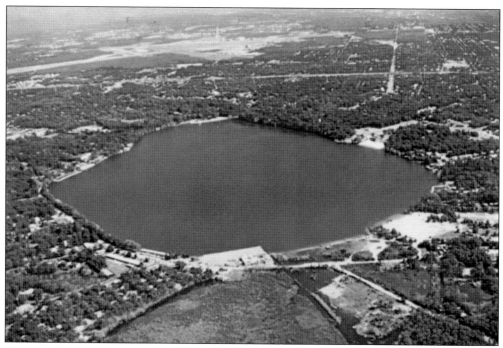

The area directly to the north of Lake Ronkonkoma is known as the Great Swamp, which is supplied with water from the north through a series of underground streams. There is one inlet from the swamp that feeds water directly into the lake. A 70-foot-deep area near the southern end of the lake, known to local people as "the Hole," connects with the glacial aquifer. This is the upper water table under Long Island. Changes in the level of the water in this water table cause the level of water in the lake to rise and fall dramatically over long periods of time. The 1973 postcard above shows the Great Swamp in the foreground. The beautiful photograph shown below was taken in 1905 by George Warner. The inlet is shown with the north shoreline of the lake in the background.

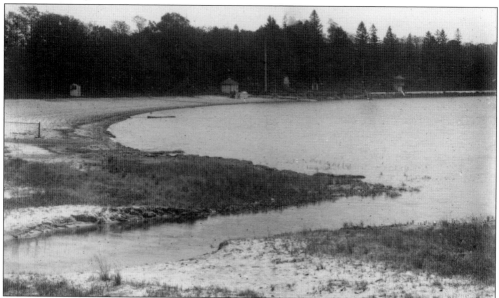

Three

THE BUSINESS LIFE

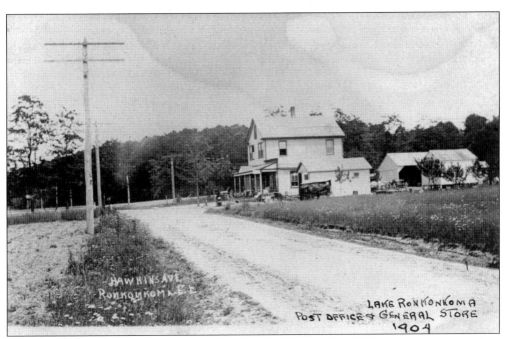

In 1898, Willis Hallock built a small one-story general store at the southeast corner of Hawkins Avenue and Farm to Market Road. By 1899, the store also included the first Lake Ronkonkoma Post Office. Soon after, he raised the building to two floors to create a living space for his family. This 1904 image looks north on Hawkins Avenue at the Hallock General Store. By 1907, Hallock sold the store to W.E. Coleman. Note the fire bell, which was made from the outer ring of a locomotive drive wheel, hanging from a tree branch in the extreme left of the photograph.

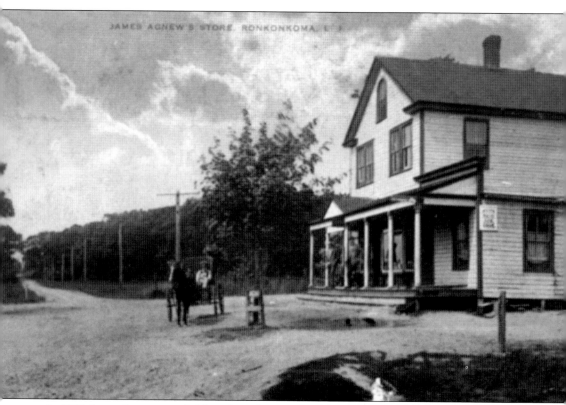

In 1913, James Agnew, a taxi driver from Coney Island, brought a fare out to Lake Ronkonkoma. He stopped at the local general store, the W.E. Coleman store, and noticed it was for sale. He got together with his brother-in-law Ike Taylor to buy the store, and they called their new establishment Agnew and Taylor. James Agnew and his two sons operated Agnew and Taylor for over 60 years as a general store and hardware store. This postcard looking north on Hawkins Avenue shows the store a year after James Agnew purchased it. Over the next few years, Agnew and Taylor would add gas pumps and oil to serve the growing number of motorists in the area.

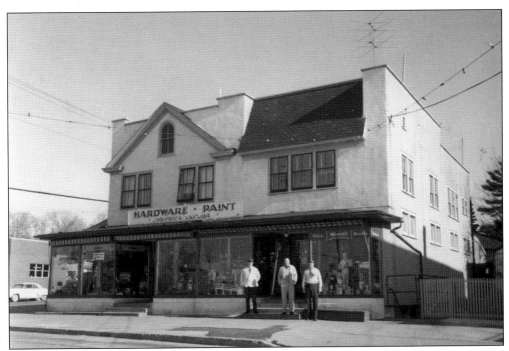

Over the six decades that the Agnew family operated the Agnew and Taylor store, the town and the business district grew up around them. Over time, the general store slowly turned into a hardware and paint store. They also added a second floor addition to the south side of the building. The Agnews, Bill (left), James (center), and Jim, are pictured here in front of their store in 1961.

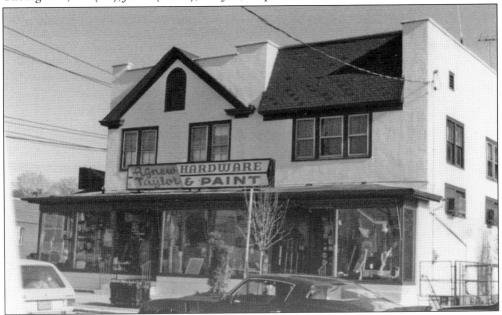

After James Agnew retired, his two sons operated the store for a number of years. In 1971, they retired and leased the business until 1984. The McDonald's Corporation owned the store for a brief period until 1985, when Paul and Sandy Weber bought the store. They proudly operate this town landmark today.

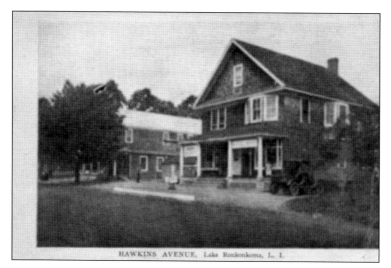

HAWKINS AVENUE, Lake Ronkonkoma, L. I.

Around 1908, the W.H. Callmeyer store was built on the east side of Hawkins Avenue next to the general store. Callmeyer's store featured a butcher shop and a small ice cream shop. This late-1920s image shows the Callmeyer store on the right, with Agnew and Taylor to the left. (Courtesy of Quinn Vollgraff and Les Hanak.)

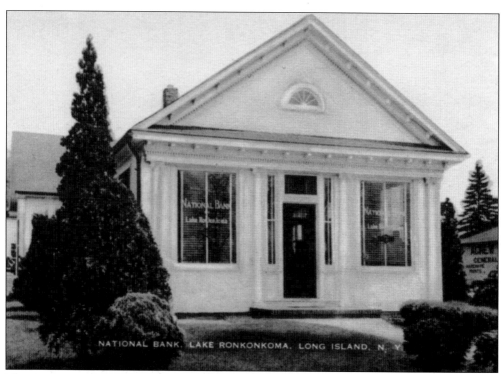

NATIONAL BANK, LAKE RONKONKOMA, LONG ISLAND, N. Y.

The First National Bank of Lake Ronkonkoma, which was the first bank built in Lake Ronkonkoma, opened for business on April 9, 1928. The bank was located on the northeast corner of Hawkins Avenue and Portion Road. It took in $43,000 in deposits on its first day. The bank was organized in September 1927 by a group of prominent local businessmen, including George C. Raynor, Louis Heilman, James Agnew, Joseph Kirk, Clarence Dare, and Giles Degroot.

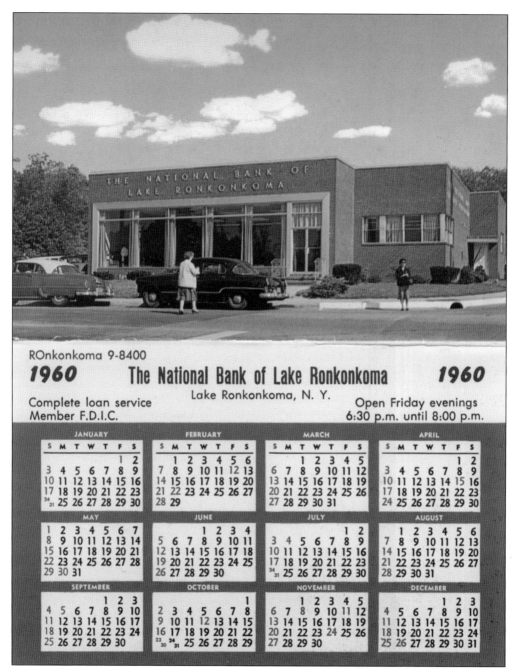

ROnkonkoma 9-8400

1960 **The National Bank of Lake Ronkonkoma** *1960*

Lake Ronkonkoma, N. Y.

Complete loan service
Member F.D.I.C.

Open Friday evenings
6:30 p.m. until 8:00 p.m.

JANUARY	FEBRUARY	MARCH	APRIL
S M T W T F S	S M T W T F S	S M T W T F S	S M T W T F S
1 2	1 2 3 4 5 6	1 2 3 4 5	1 2
3 4 5 6 7 8 9	7 8 9 10 11 12 13	6 7 8 9 10 11 12	3 4 5 6 7 8 9
10 11 12 13 14 15 16	14 15 16 17 18 19 20	13 14 15 16 17 18 19	10 11 12 13 14 15 16
17 18 19 20 21 22 23	21 22 23 24 25 26 27	20 21 22 23 24 25 26	17 18 19 20 21 22 23
24 31 25 26 27 28 29 30	28 29	27 28 29 30 31	24 25 26 27 28 29 30

MAY	JUNE	JULY	AUGUST
S M T W T F S	S M T W T F S	S M T W T F S	S M T W T F S
1 2 3 4 5 6 7	1 2 3 4	1 2	1 2 3 4 5 6
8 9 10 11 12 13 14	5 6 7 8 9 10 11	3 4 5 6 7 8 9	7 8 9 10 11 12 13
15 16 17 18 19 20 21	12 13 14 15 16 17 18	10 11 12 13 14 15 16	14 15 16 17 18 19 20
22 23 24 25 26 27 28	19 20 21 22 23 24 25	17 18 19 20 21 22 23	21 22 23 24 25 26 27
29 30 31	26 27 28 29 30	24 31 25 26 27 28 29 30	28 29 30 31

SEPTEMBER	OCTOBER	NOVEMBER	DECEMBER
S M T W T F S	S M T W T F S	S M T W T F S	S M T W T F S
1 2 3	1	1 2 3 4 5	1 2 3
4 5 6 7 8 9 10	2 3 4 5 6 7 8	6 7 8 9 10 11 12	4 5 6 7 8 9 10
11 12 13 14 15 16 17	9 10 11 12 13 14 15	13 14 15 16 17 18 19	11 12 13 14 15 16 17
18 19 20 21 22 23 24	16 17 18 19 20 21 22	20 21 22 23 24 25 26	18 19 20 21 22 23 24
25 26 27 28 29 30	23 30 24 31 25 26 27 28 29	27 28 29 30	25 26 27 28 29 30 31

This 1960 calendar shows what the National Bank of Lake Ronkonkoma looked like after a renovation to enlarge the building. Many years after this photograph was taken, the building was bought by the Lake Ronkonkoma Fire District, which still uses it for training, a polling place on election days, and a venue rented out for various functions. The original bank vault can still be seen inside. (Courtesy of Quinn Vollgraff and Les Hanak.)

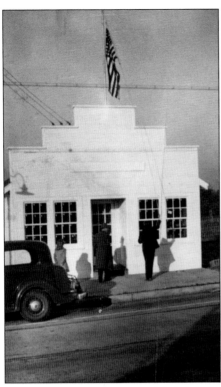

The Lake Ronkonkoma Post Office building on the west side of Hawkins Avenue opened on November 3, 1941. This was the first time the post office was located in its own building. It had previously been located within the Agnew and Taylor store and then Geweilers store.

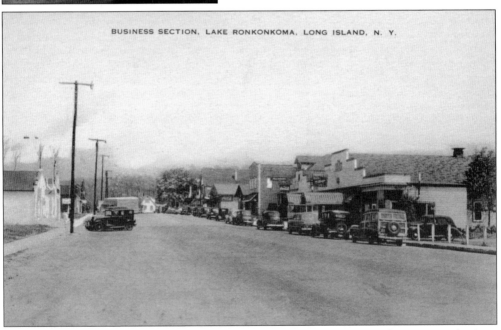

BUSINESS SECTION, LAKE RONKONKOMA, LONG ISLAND, N. Y.

As the number of people in Lake Ronkonkoma kept growing, the Hawkins Avenue business district became more congested, and traffic on narrow Hawkins Avenue became a problem. In the mid-1940s, a road-widening project began. All the stores on the west side of Hawkins Avenue were moved back a number of feet to create a wider road. This postcard shows Hawkins Avenue looking north shortly after the project was completed.

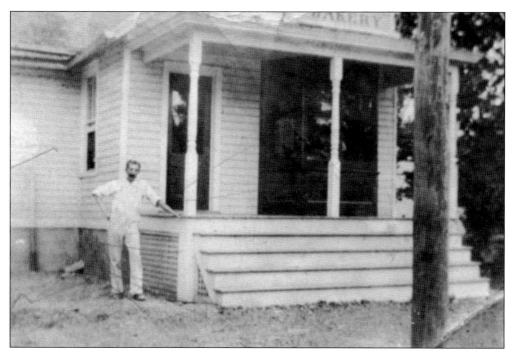

Brooklyn residents Daniel and Lena Seibert built a summer bungalow in Lake Ronkonkoma in 1910. Their son Charles was sickly, and their doctor advised country air as a cure. In February 1924, Daniel quit his job as a baker in Brooklyn and bought the bakery owned by E. Hinze on Hawkins Avenue. He named it Seiberts Bakery. Business was booming, and they soon started a home-delivery service with two wagons. One was pulled by a horse, and the other was pulled by a mule. In the photograph above Daniel Seibert stands in front of the bakery building on Hawkins Avenue, which had also been expanded into a fine home for the Seiberts and their five children. In the photograph below, the four Seibert delivery trucks are parked in front of the Seibert barn and garage.

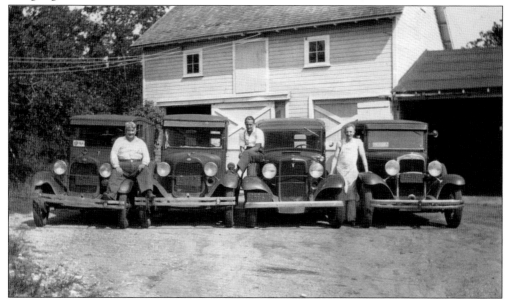

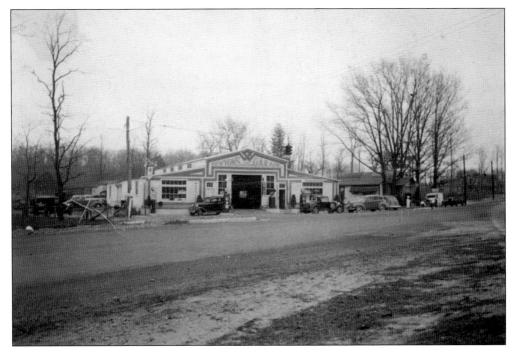

The Newton family was among the earliest settlers of the Lake Ronkonkoma area. In 1921, Dick and Sumner Newton opened an automobile-repair shop on Portion Road. They named their business Newton's Garage and operated the business for almost 40 years. After a couple of years of successful operation, they added an island with two gasoline pumps. The garage is pictured above around 1938, and the 1961 building below is still operating as a repair shop today.

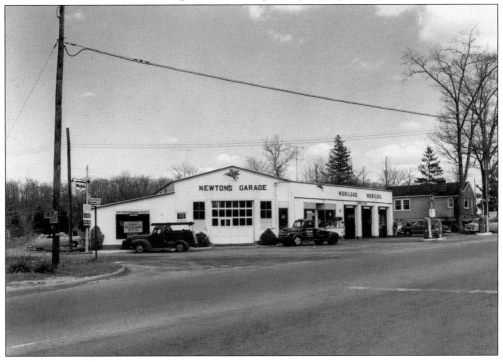

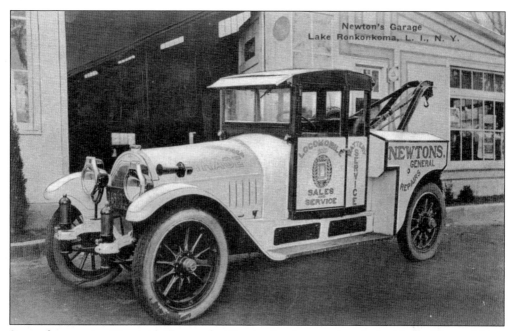

Soon after opening Newton's Garage, the Newton brothers made a deal with the Durant Motor Company, a producer of luxury cars, to become the local dealer for Durant's Locomobile. The company converted a 1916 Locomobile into the beautiful custom Locomobile tow truck for the Newton brothers. (Courtesy of Quinn Vollgraff and Les Hanak.)

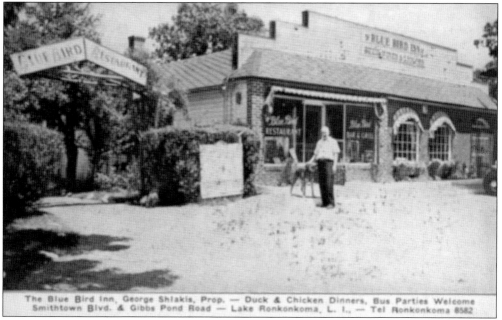

The Blue Bird Inn was an excellent restaurant located at the corner of Smithtown Boulevard and Gibbs Pond Road, owned by George Shlakis. The Blue Bird featured homemade meals and was a favorite among local residents. Even though the Blue Bird Inn is long gone, Lake Ronkonkoma residents still rave about the great food and memories created there. Note Smiley the dog next to Shlakis. (Courtesy of Quinn Vollgraff and Les Hanak.)

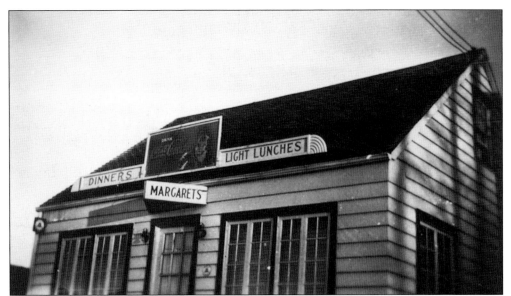

Margaret's was located on the north side of Portion Road just west of the firehouse. Margaret Curtis opened this restaurant in 1942 with her sister Kitty Curtis, and they named it We Three. Eventually, Kitty left the business, and Margaret ran it with her husband, Walter. They renamed the place Margaret's and catered to the locals. The home-cooked food such as roast beef, pies, and her famous shrimp and macaroni salad bought in crowds every day.

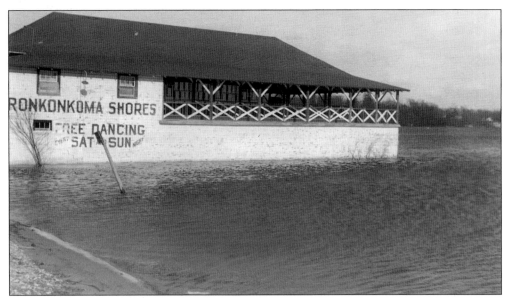

The Ronkonkoma Shores Beach was a popular beach on the north side of the lake in the mid-1930s. A small refreshment stand on the beach sold food and drinks, and as the business flourished, the owners added a small restaurant. By 1939, a small dance hall pavilion was built on the beach, but in 1940, the rising waters of the lake surrounded this building. It was later moved to the rear of the property next to Smithtown Boulevard and eventually became part of the Bavarian Inn.

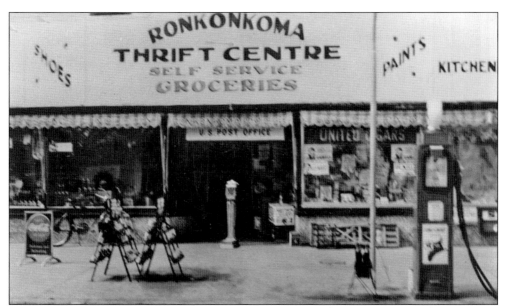

The Ronkonkoma Thrift Center was located on Railroad Avenue, across from the Ronkonkoma train station. Formally known as Krasdales, the thrift center sold a wide variety of items: gasoline, shoes, cigars, sodas, candy, paint, and groceries just to name a few. It also included a branch of the Ronkonkoma Post Office. (Courtesy of Quinn Vollgraff and Les Hanak.)

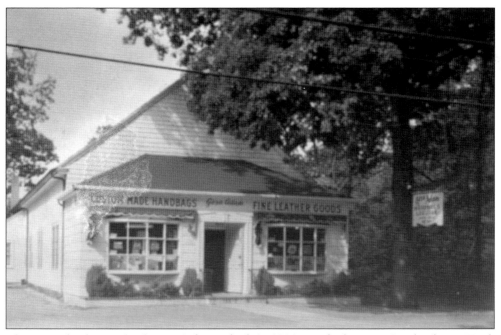

The original Lake Ronkonkoma Firehouse, built in 1906, was the home to Ronkonkoma Hook and Ladder Company No. 1 until 1923. The building survives to this day. This is what the building looked like in the 1960s, when it was known as the Geza Adam Handbag Factory. (Courtesy of Quinn Vollgraff and Les Hanak.)

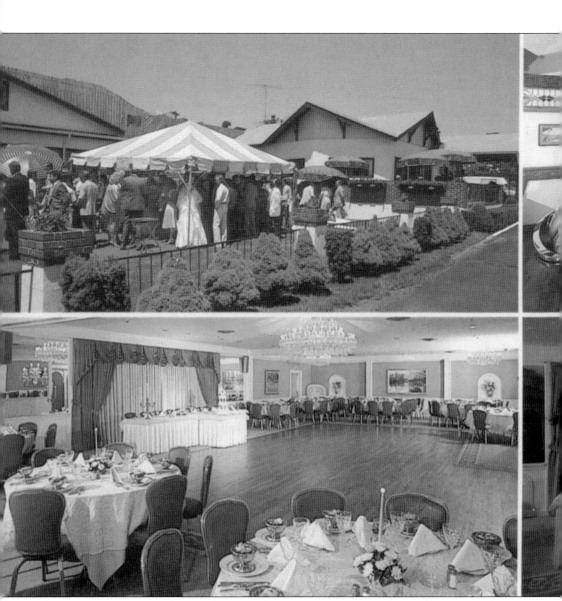

The Bavarian Inn was a landmark in Lake Ronkonkoma from the late 1950s until its closing in 2007. People from all parts of Long Island went to this beautiful catering hall for weddings, birthday parties, holidays, business meetings, or just for a great German meal. This brochure shows various

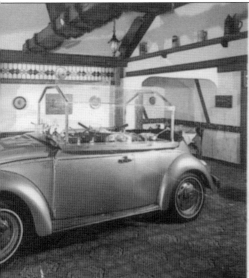

scenes at the Bavarian, including the Volkswagen Bug salad bar. (Courtesy of Quinn Vollgraff and Les Hanak.)

When William Huber Sr. bought the Ronkonkoma Shores Beach and Restaurant in the mid-1930s, it was a swimming beach with a small hot-dog stand. Huber took the income the business was earning and started to build his version of a fine catering hall with delicious German cuisine. The 1940s addition of a cabaret with dancing on the weekends led to the transformation into a catering facility. By 1955, he changed the name to the Bavarian Inn. Generations of Long Islanders still share memories of weddings, graduations, and parties held at this Lake Ronkonkoma landmark. (Courtesy of Quinn Vollgraff and Les Hanak.)

73

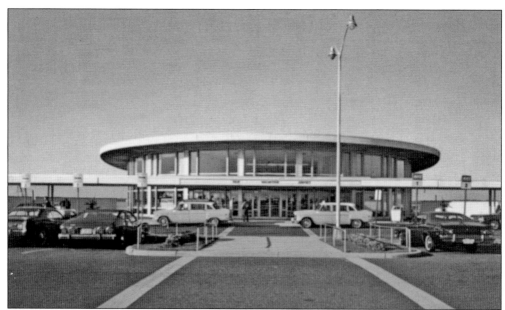

Islip Airport was first organized as a base for military planes in April 1942, when the town of Islip contracted with the federal government to build a military airport on town-owned land. After the war ended, it took on a new life as a small regional airport and was named MacArthur Airport in honor of Gen. Douglas MacArthur. The General Douglas MacArthur Terminal, operated by the town of Islip, is pictured here.

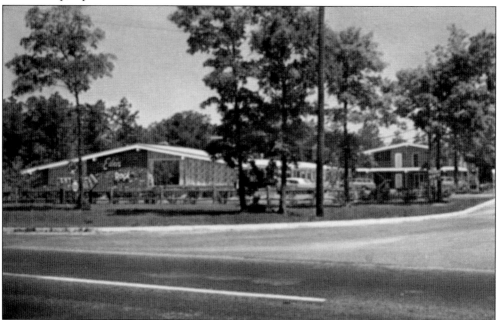

One of the motels that was built to serve the new Long Island MacArthur Airport was the Eden Rock Motel. The motel was located on Veteran's Memorial Highway, just a short drive from the airport. The Eden Rock featured modest accommodations at reasonable rates, and the motel still serves travelers today under the Econo Lodge name. (Courtesy of Quinn Vollgraff and Les Hanak.)

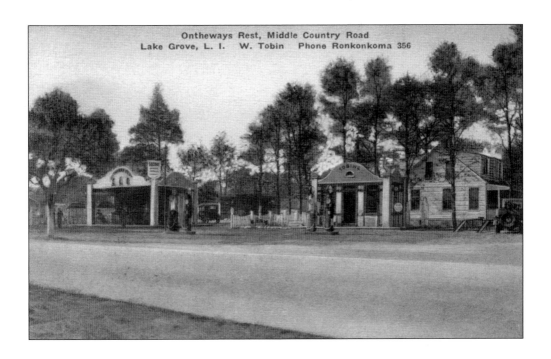

On the Way Rest, Middle Country Road
Lake Grove, L. I. W. Tobin Phone Ronkonkoma 356

The On the Way Rest was a roadside rest stop and gas station built in the 1920s to cater to the automobile travelers, located on the northwest corner of Hawkins Avenue and Middle Country Road. Drivers could stop for a quick meal and fill their gas tanks. Above is the On the Way Rest on the left and Tobins, the small gas station on the right. By the 1940s, the Bednar family bought the property and opened Bednar's Service Station, which is pictured below. (Both, courtesy of Quinn Vollgraff and Les Hanak.)

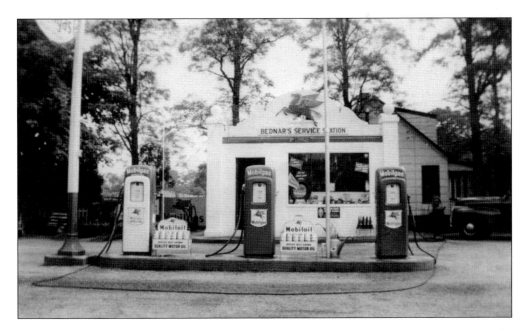

The Green Parrot Tourist Inn and Cabins, owned by Mildred and Frank Cashmore, were located on Smithtown Boulevard west of Gibbs Pond Road. The business consisted of a large inn surrounded by eight cabins of various sizes, and bathrooms and showers were located in the center courtyard. The Green Parrot was extremely popular among summer tourists due to its close proximity to the lake itself. The Green Parrot was sold by Mildred and Frank Cashmore in 1961 and operates as a residential rental community today.

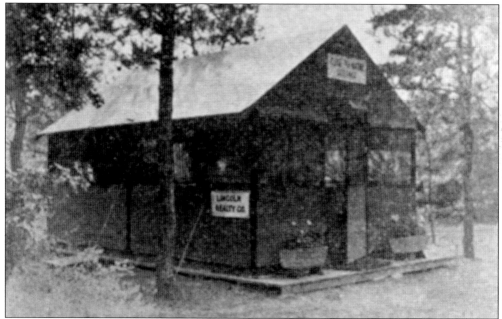

The growing popularity of Lake Ronkonkoma at the dawn of the 20th century created a demand for summer homes in the area. Companies such as M.G Babcock, the Lincoln Realty Company, C.H. Reilly, and Richmond Gardens Realty, to name a few, gave their developments special names such as Ronkonkoma Hills or Ronkonkoma Heights to attract customers. The Lincoln Realty office in Lake Ronkonkoma is shown here.

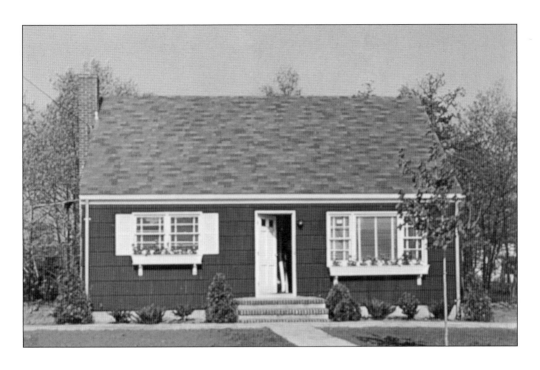

In the years following World War II, the lake attracted more New York City–area couples looking to start a life in suburbia. The real-estate companies started offering more home-like designs rather than summer bungalows. This postcard advertised the Pilgrim, a four-bedroom house design. By the late 1960s, thousands of such homes had been built in the town of Lake Ronkonkoma. (Both, courtesy of Quinn Vollgraff and Les Hanak.)

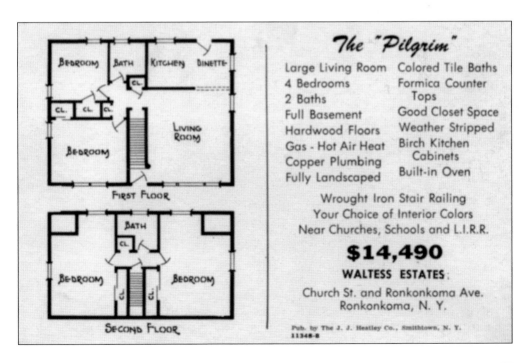

The "Pilgrim"

Large Living Room	Colored Tile Baths
4 Bedrooms	Formica Counter
2 Baths	Tops
Full Basement	Good Closet Space
Hardwood Floors	Weather Stripped
Gas - Hot Air Heat	Birch Kitchen
Copper Plumbing	Cabinets
Fully Landscaped	Built-in Oven

Wrought Iron Stair Railing
Your Choice of Interior Colors
Near Churches, Schools and L.I.R.R.

$14,490

WALTESS ESTATES

Church St. and Ronkonkoma Ave.
Ronkonkoma, N. Y.

Pub. by The J. J. Heatley Co., Smithtown, N. Y.
11346-8

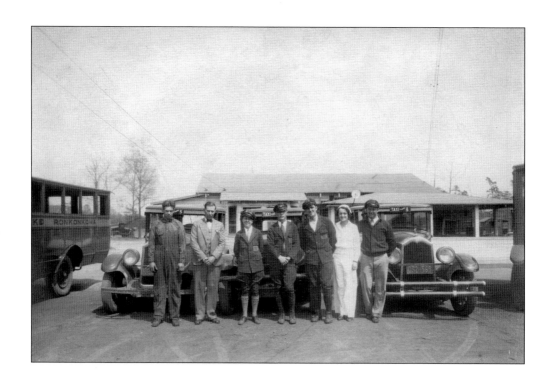

Hawkins Taxi opened on Ronkonkoma Avenue during the early 1920s. Owner Dot Hawkins bought a number of taxi cabs and two buses to capitalize on the crowds of tourists coming to Lake Ronkonkoma in the summertime. The rare photograph above shows Hawkins (second from right) and her crew standing proudly in front of her fleet of taxis and buses. Shown below is a Hawkins Taxi Company Bus bringing Lake Ronkonkoma students to West Meadow Beach, a beach on the north shore of Long Island, for the annual graduation picnic.

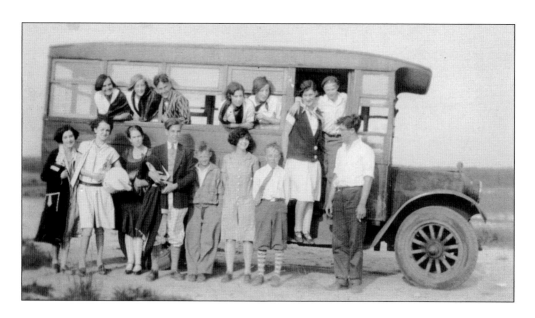

Four

SCHOOLS AND CHURCHES

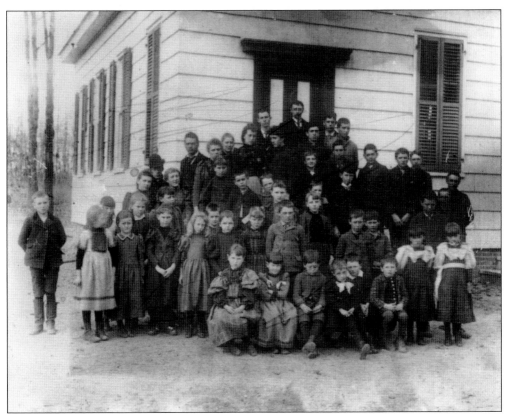

The Lake Grove and Ronkonkoma School, which was sometimes called the Lakeville School, was a one-room schoolhouse. It was the first school in the area, built in 1812 and served the area as an elementary school until 1912. Ronkonkoma had no high school, so after graduating from this school, students would have to travel to Sayville or Patchogue if they wished to continue with their education. The class of 1893 is pictured here.

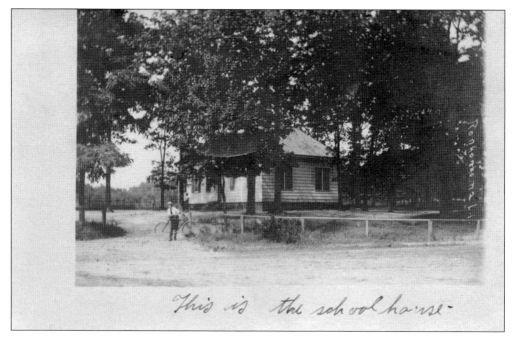

The Lake Grove and Ronkonkoma School was built in 1812 at the corner where Smith Road, Hawkins Avenue, and Gatelot Avenue all met. In the early years, students of all grades, first through eighth, learned in the same classroom. By the 1850s, the school was expanded so that it now held two classrooms. This expansion also created a meeting place for the local Methodist congregation that had been meeting at Amzie Newton's house. These two images postmarked July 10, 1908, (top) and May 21, 1909, (bottom) provide different views of the school. In 1912, a new school was built, and the original school building was sold to the Lake Grove Athletic Association.

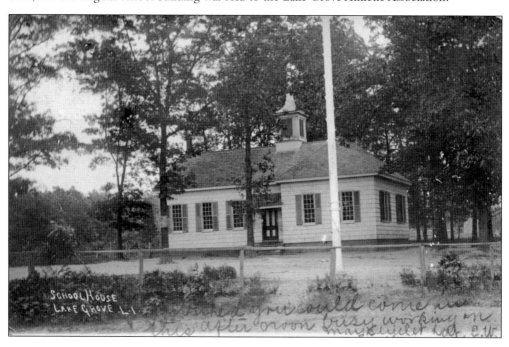

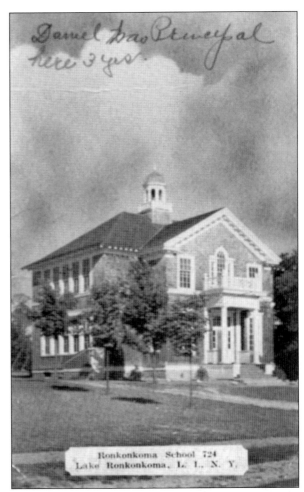

Daniel [...] Principal
here 3 yrs.

The population of Ronkonkoma was growing, and in 1911 a larger schoolhouse located closer to the center of town was planned. A plot of land on Hawkins Avenue was purchased from Frank L. Newton, and in 1912 the Lake Ronkonkoma School, a modern four-room schoolhouse was built. The new Lake Ronkonkoma Schoolhouse had four classrooms, enabling students to learn together with other children their own age. The postcard at right shows the Lake Ronkonkoma School around 1935. The image below from 1936 shows a physical education class in the yard behind the schoolhouse. In 1924, a fourth teacher was hired to help serve the growing student population. In 1925 and 1928, additional land was purchased around the school, bringing the size of the property to 3.5 acres. (Right, courtesy of Quinn Vollgraff and Les Hanak.)

Ronkonkoma School 724
Lake Ronkonkoma, L. I., N. Y.

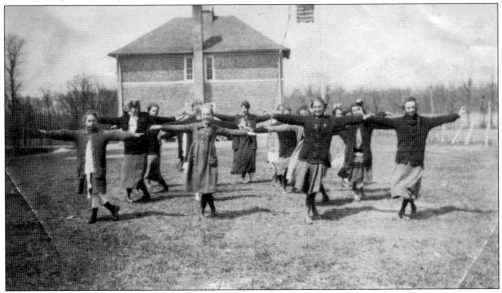

Ronkonkoma School

District No. 11

Islip, Suffolk Co., New York

June 12, 1931

Evelyn Emery,

~~Principal~~
Teacher

School Board

Joseph Buchler Walter Stecker

Joseph Kirk

Pupils

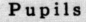

THIRD AND FOURTH GRADES

Boys

John Szolosi	Martin Knobloch
Joseph Kerstner	Frederick Kraics
James Fenyak	Louis Pokorny
Lawrence Holzapfel	Frank Holzler
Edward Hanak	Andrew Szolosi
Edward McDonald	John Gimmler
Jack Edwards	Charles Holzler
Alex Cherry	

Girls

Beatrice Stecker	Mary Hodl
Margaret Edwards	Audrey Pittman
Mildred Lutz	Katherine Beckert
Lurine Pamlanye	Elizabeth Tangel
Elizabeth Rosch	Mary Rosch
Margaret Feher	

In the early years of the 20th century, teachers would give souvenir books to all their graduating students. The third and fourth graders of the Lake Ronkonkoma School, who shared a single classroom in the four-room schoolhouse, were presented with this booklet on June 12, 1931. Even though thousands of people came to Lake Ronkonkoma in the summer, the third and fourth grade class numbered just 26 students.

An arson fire on January 4, 1946, destroyed the Lake Ronkonkoma Schoolhouse, leaving the town without a school. Plans to replace the four-room schoolhouse began shortly after the fire. A plot of land to the east of the old school was purchased from Charles Hawkins. Architect Daniel Perry was hired to design a new school. Construction began in 1947. During this time, Ronkonkoma students had to travel north to the Lake Grove School on Parsnip Pond Road to be educated. The image at right shows Phillip Hans, then-president of the board of education, laying the cornerstone as young Lance Hugelmeyer looks on in 1947. The postcard below shows the new Lake Ronkonkoma Elementary School, located at the northeast corner of Gatelot and School Streets, in 1948. The school still serves the school district today and is now known as Gatelot Elementary School.

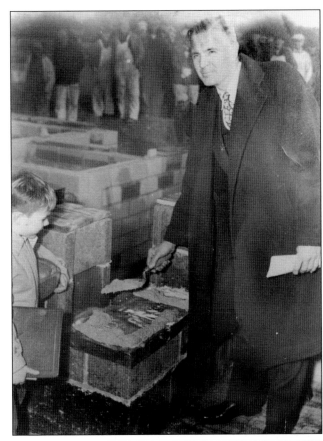

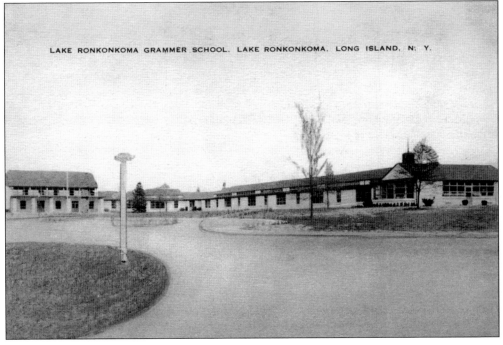

LAKE RONKONKOMA GRAMMER SCHOOL. LAKE RONKONKOMA. LONG ISLAND. N. Y.

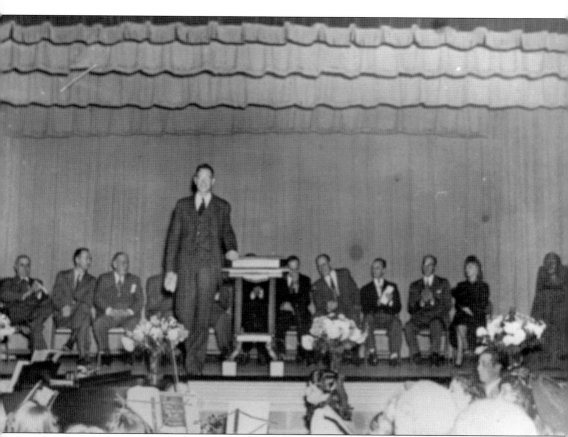

The new Lake Ronkonkoma Elementary School was dedicated on November 17, 1948. The evening included a performance from the school orchestra and the glee club, and school board president Phillip Hans gave the welcoming address. PTA president Lillian Sevenliss presented a bust (far right) of longtime school custodian Thomas Fish to his family. School principal Walter C. Dunham (standing) is shown speaking at the dedication.

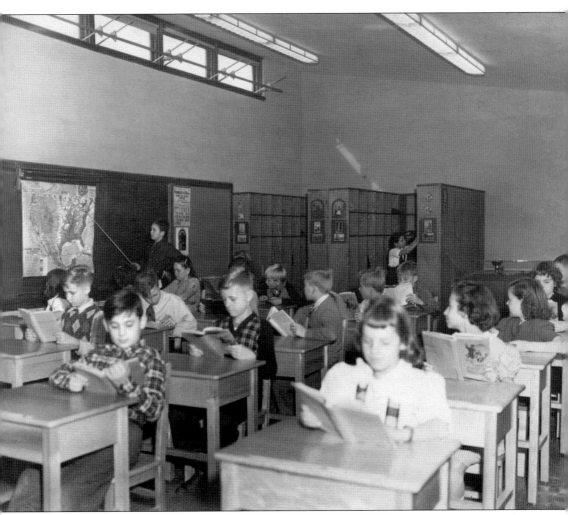

The Lake Ronkonkoma Elementary School dedicated in 1948 was the first postwar school built on Long Island. It featured new innovations in school design such as self-contained classrooms that included bathrooms and water fountains. This image from 1949 shows a class in session in the new school; note the water fountain in the back of the classroom.

The Winwood School was a private school that operated in the village of Lake Grove at the corner of Moriches Road and Parsnip Pond Road. This double-sized postcard displays a view of the school grounds. Parsnip Pond Road can be seen running into the distance on the left. The

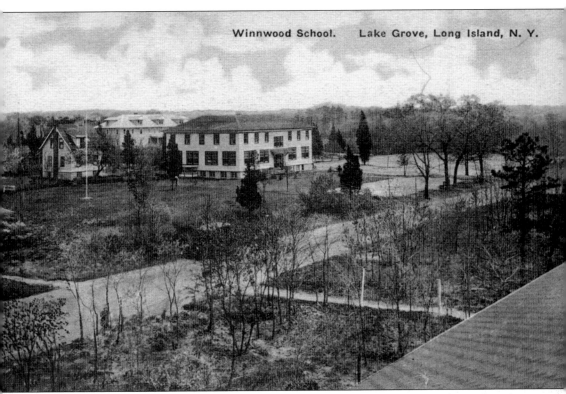

Winnwood School. Lake Grove, Long Island, N. Y.

photograph for this postcard was taken from the roof of the school gymnasium by Robert S. Feather. (Courtesy of Quinn Vollgraff and Les Hanak.)

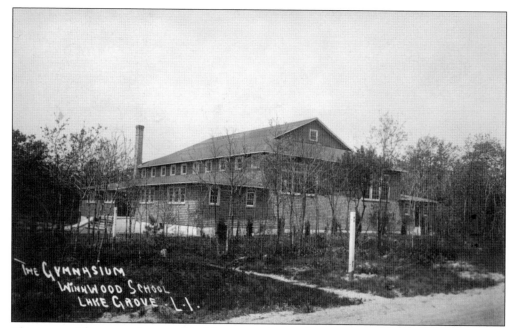

This postcard features a photograph of the gymnasium at the Winwood School. This building was located just across the street from the school on Moriches Road, and behind the gym was a large athletic field. The gymnasium was destroyed by fire in 1987. (Courtesy of Quinn Vollgraff and Les Hanak.)

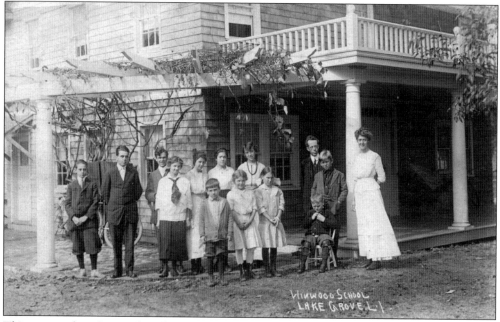

This group of teachers and students is standing in front of one of the classroom buildings at the Winwood School. Ronkonkoma resident Jessamine Hawkins is shown fifth from the left. Various owners operated the school during the 20th century, and it was called the Lake Grove School from 1940 until its closing in 2013.

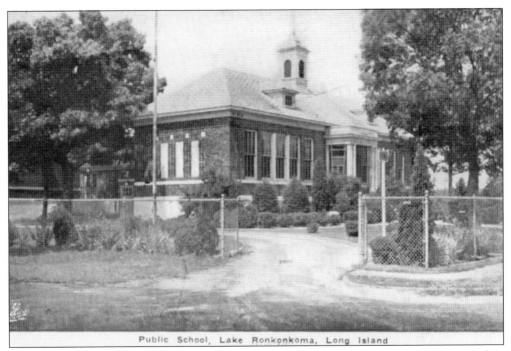

Public School, Lake Ronkonkoma, Long Island

The Edith Slocum School, earlier known as the Ronkonkoma Grammar School, was dedicated on September 13, 1924. It was built for $25,000 as a replacement for the 1873 Ronkonkoma School that occupied the same location. There was a rapid growth in the population of the area, and this caused the new school to be overcrowded from the day it opened. They improvised classrooms in the hallways until a new addition was built in 1927 at a cost of $35,000. The school still operates today as part of the Connetquot School District. (Courtesy of Quinn Vollgraff and Les Hanak.)

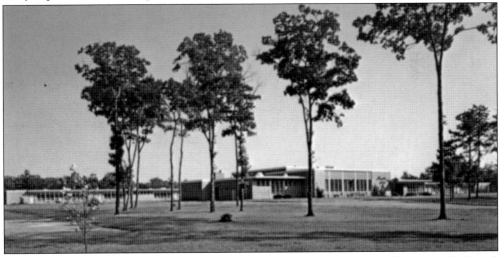

Hiawatha Elementary School was built in 1963 on Patchogue Road (today Patchogue-Holbrook Road) in Lake Ronkonkoma. Though the school was built in 1963, the first class did not attend until September 1964. The school was designed to educate 700 students, but by 1969 the school had 1,400 students and had to operate on split sessions. Since then, there have been three additions to the original building, an updated kindergarten wing, and an expanded library. The school is still open today.

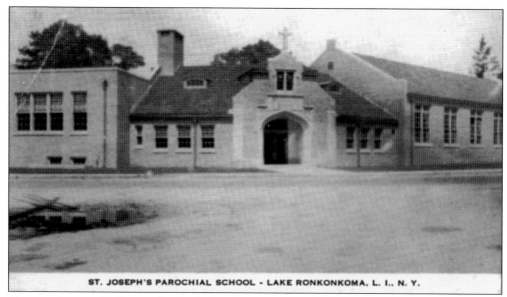

ST. JOSEPH'S PAROCHIAL SCHOOL - LAKE RONKONKOMA, L. I., N. Y.

Construction on the St. Joseph Parochial School located on Church Street began in late 1949. It was dedicated on June 18, 1950, and the original school had four classrooms and an auditorium. The school officially opened to students on September 11, 1950, with 180 students in grades one to six. In 1952, enrollment had grown so fast that four new classrooms were added to the building. In 1960, a new building with an additional eight classrooms, a library, and additional administrative offices was constructed.

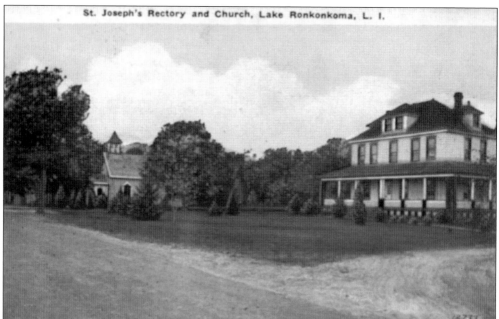

St. Joseph's Rectory and Church, Lake Ronkonkoma, L. I.

St. Joseph's Catholic Church, located on Church Street, was organized in 1884 and operated as a mission church until 1901. Local resident Martin Metzner was a major financial backer, and when the church first opened, the parish included only 12 Catholic families. By 1910, the church had gained full-time parish status. The postcard here shows the original church building on the left and the rectory on the right as they looked in 1932.

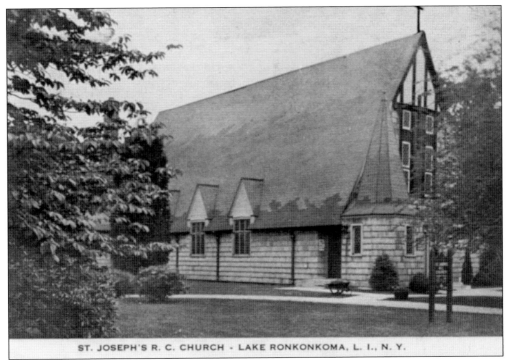

ST. JOSEPH'S R. C. CHURCH - LAKE RONKONKOMA, L. I., N. Y.

As the town population grew, the original church building became too small to accommodate the growing number of parishioners. A new larger church was built in 1931 and dedicated on July 4, 1931. The original church became the parish hall, and the new church served the parish until 1968, when the church was replaced again with a modern building that serves the parish to this day.

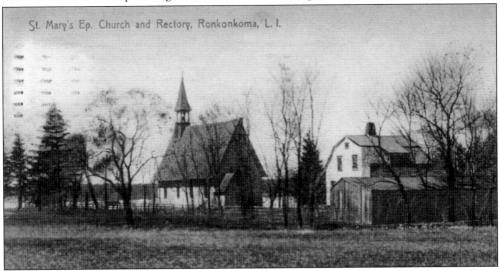

St. Mary's Ep. Church and Rectory, Ronkonkoma, L. I.

In 1867, Col. John Puleston, a retired member of the British Parliament and his wife, Margaret, donated a plot of land overlooking Lake Ronkonkoma for the purpose of building an Episcopal church. The wealthy Pulestons funded the construction, and when the church was completed they donated a pipe organ and bishop's chair. St. Mary's Episcopal Church was dedicated on December 24, 1867, and the building served the congregation until deconsecrated and replaced with a new building in 1971. (Courtesy of Quinn Vollgraff and Les Hanak.)

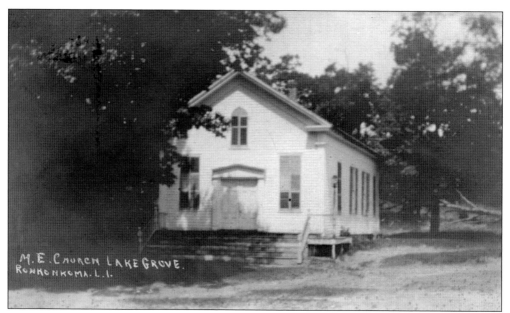

The Methodist Episcopal congregation was organized around 1780 by Caleb Newton, but by the 1830s, Newton's house became too small to host the congregation. A renovation to the one-room schoolhouse at Five Corners created a room large enough for the congregation to meet, and $700 was raised to build a small church in 1852. In April 1853, the new church, the Methodist Episcopal Church of the Neighborhood of Ronkonkoma Pond (above), was dedicated. It served the growing congregation until 1868, when a building extension added 17 feet to the front of the building, a balcony was added, and new pews were installed. In 1907, a larger church was built just east of the original. The new larger church, which opened on October 20 1907, is shown below on the right. The original 1853 church can be seen on the left. (Both, courtesy of Quinn Vollgraff and Les Hanak.)

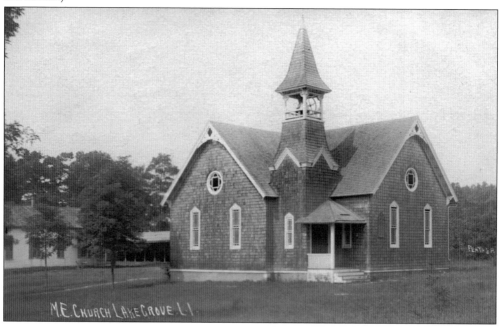

Five

TOWN SERVICES

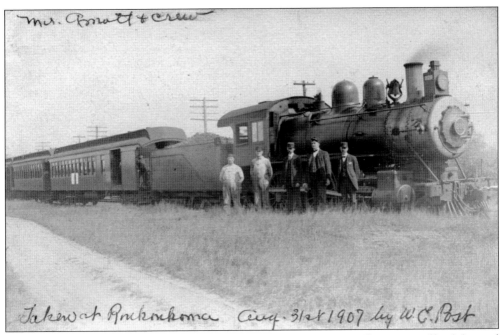

Mr. Amott & crew

Taken at Ronkonkoma Aug. 31st 1907 by W.C. Post

The Ronkonkoma Train Station and train yard were built in 1883 on a large tract of land donated to the Long Island Railroad by the Newton and Puleston families. Local residents contributed the $300 necessary to build the new station, and many railroad employees had homes built in the area around the new station. This 1907 postcard of Ronkonkoma resident William Amott and crew was taken in the Ronkonkoma Train Yard by William Post, who also lived in Ronkonkoma.

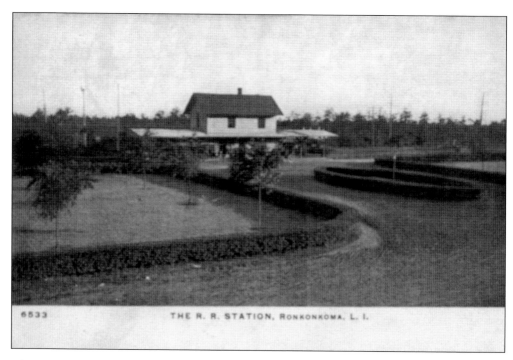

THE R. R. STATION, RONKONKOMA, L. I.

6533

The need for a train station in Ronkonkoma had become apparent to Long Island Railroad officials by 1882. Most of the passenger traffic at the Lakeland Station located one mile to the west involved Lake Ronkonkoma, so in 1883, the Ronkonkoma Station replaced Lakeland. Giles C. Degroot became the first station agent. In 1900, local resident and famous actress Maude Adams donated money to have the station grounds landscaped with hedges, elm trees, lawns, and gravel driveways. The images on this page display the impressive results. In the image below, the hotels that have been built along Railroad Avenue can be seen to the left. The two small buildings to the far right are the freight buildings.

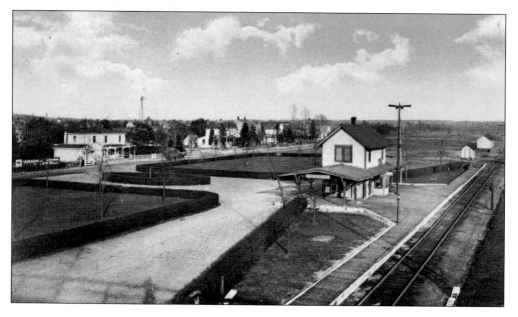

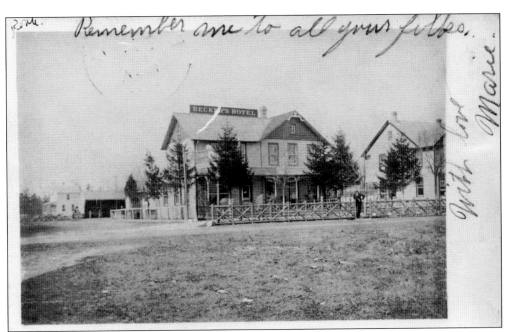

Becker's Hotel was one of the first-class hotels that opened on Railroad Avenue after the Ronkonkoma train station was built in 1883. The hotel was owned by Edward Becker and pictured here on the postcard above postmarked June 13, 1907. The small dirt road in front of the hotel is Railroad Avenue. The Beckers sold the hotel around 1915, and it eventually became a residential rental building. In the image below from 1970, a one-story building has been added to the front of the original hotel building. (Above, courtesy of Quinn Vollgraff and Les Hanak.)

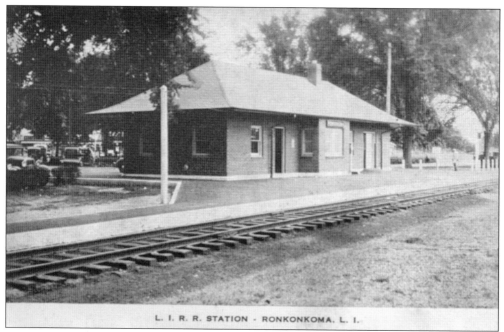

L. I. R. R. STATION - RONKONKOMA, L. I.

On February 6, 1933, the original Ronkonkoma Station burned to the ground as a result of a defective flue. The railroad replaced the station with a small shack, and Lake Ronkonkoma residents and commuters protested to the railroad. Most refused to enter "the disheveled chicken shack," as they called it, waiting in their cars in the winter for their train. The railroad relented, and in early 1937 construction of a new train station began. The new station was dedicated on August 21, 1937. Note the two different names above the freight wagon in the 1952 nighttime photograph below. This station was razed in 1994, a few years after the current Ronkonkoma Terminal had been built.

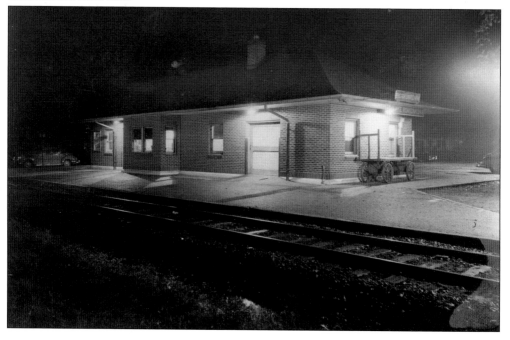

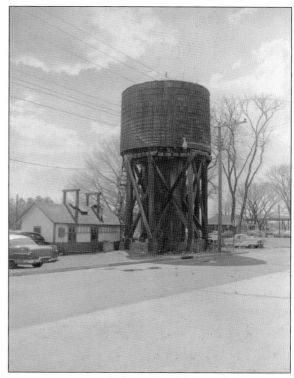

By the time the photograph at right was taken on April 4, 1961, the water tower on the north side of the station was just a relic of the steam-train era. The last steam engine on the Long Island Railroad had run in October 1955. Just to the left of the tower in this photograph is the freight express house, which was moved from the southeast end of the station property by the time the aerial photograph of the station property (shown below) was taken on September 28, 1963. The water tower has since been demolished. The area just left of the station house has been redesigned for parking, and the two stately elm trees donated by Maude Adams in 1900 have been cut down.

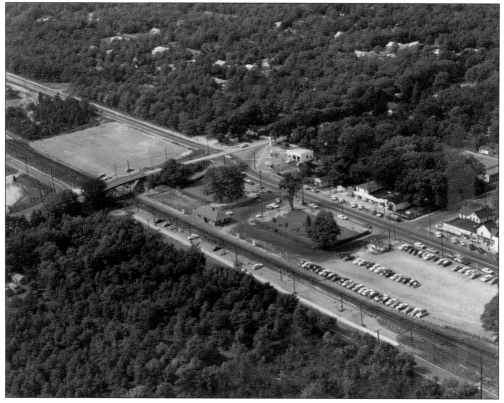

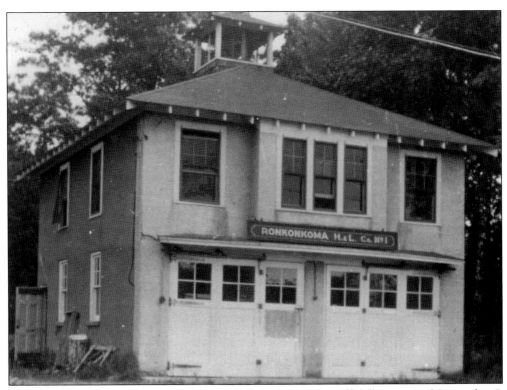

The Ronkonkoma Fire Company and Improvement Association officially organized September 5, 1903, and the goals of the association were to fight fires and improve area roads. The fire fighting unit Ronkonkoma Hook and Ladder Co. No. 1 operated out of the original firehouse on Hawkins Avenue from 1906 to 1924. On August 4, 1924, a new larger firehouse was dedicated on Portion Road. The image above shows the new firehouse. The all-volunteer organization depended on the townspeople to support it financially, and fundraisers such as plays, bingo games, and a large summer fair were well attended by Lake Ronkonkoma residents. Below is a ticket for a fundraiser at the firehouse.

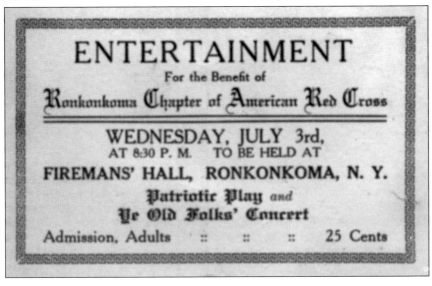

ENTERTAINMENT
For the Benefit of
Ronkonkoma Chapter of American Red Cross

WEDNESDAY, JULY 3rd,
AT 8:30 P. M. TO BE HELD AT
FIREMANS' HALL, RONKONKOMA, N. Y.
Patriotic Play and
Ye Old Folks' Concert
Admission, Adults :: :: :: 25 Cents

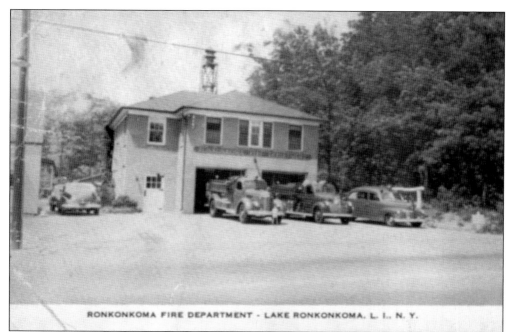

RONKONKOMA FIRE DEPARTMENT · LAKE RONKONKOMA, L. I., N. Y.

The Ronkonkoma Hook and Ladder Company No. 1 building served the community for 54 years until 1978, when it was replaced by the modern firehouse that is still in use today. On July 17, 1933, the name of the organization was officially changed to the Ronkonkoma Fire Department. In the image above, one of the many additions to the building can be seen. Note the original fire bell on the display to the far right, behind the ambulance. The seasonal greeting card at right shows another addition to the building, as well as the fleet of fire department vehicles.

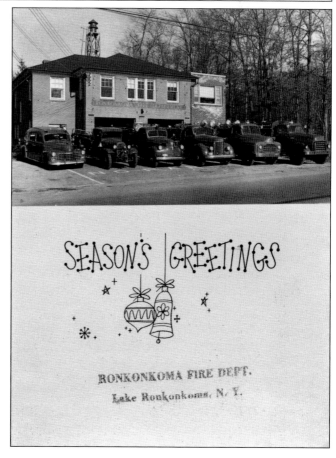

SEASON'S GREETINGS

RONKONKOMA FIRE DEPT.
Lake Ronkonkoma, N. Y.

On January 10, 1941, at a special meeting of the fire department, a motion was made to form a medical unit and buy an ambulance. With the $150 they were able to raise from bingo, a 1934 Nash was purchased, pictured above. Dr. Walter Roettinger trained the members of the new Ronkonkoma Medical Unit. Pictured at left around 1947 is the first Ronkonkoma fire truck equipped with a high-pressure piston pump doing parade duty.

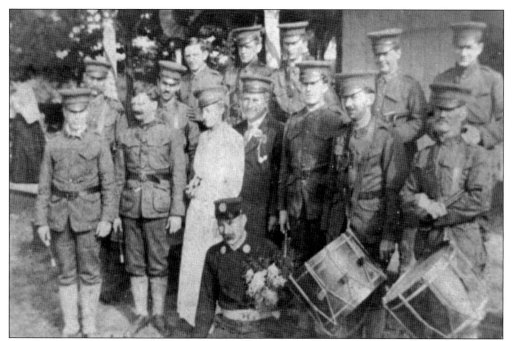

The Ronkonkoma Fire Department band was an important part of the town's social life. They marched in parades, played at fairs, and provided a great source of town pride. The fire department fair, held on the Fourth of July weekend each year, helped to bring together the townspeople from every church. Above, around 1904, the Ronkonkoma Hook and Ladder Company No. 1 poses for a photograph on the weekend of the fair. The original fire chief, John Cleary, can be seen sitting in the front. In the 1933 photograph below, the band is shown posing in front of the fire hall on Portion Road.

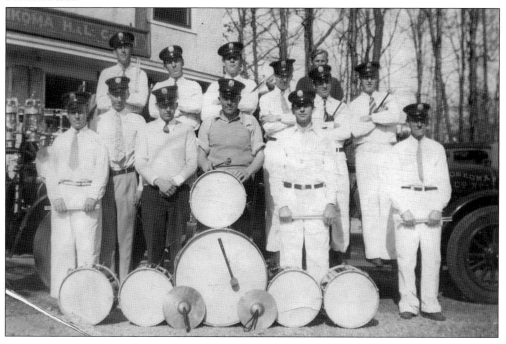

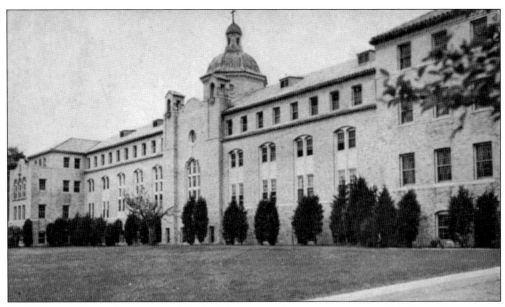

In 1921, famed Broadway actress Maude Adams, repaying a previous act of kindness, donated her 400-plus-acre farm and home in Lake Ronkonkoma to the Sisters of Saint Regis. The Sisters had kindly offered Maude a quiet room in their Retreat House on 110th Street in New York City years earlier. By 1924, the Cenacle, a large retreat house, was built on the property. The Cenacle Retreat still operates to this day.

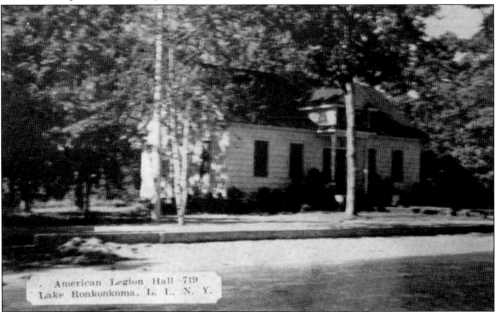

William Merritt Hallock Post 155 of the American Legion, Lake Ronkonkoma, New York, was organized in May 1926 and met in a room in Newton's Garage. The name was chosen in honor of William Merritt Hallock, a Lake Ronkonkoma resident who was killed in France during World War I. In May 1929, they opened the American Legion Hall on Church Street. The building was based on blueprints drawn by first post commander Leroy Vollgraff. This building is still in use as American Legion Post 155 to this day. (Courtesy of Quinn Vollgraff and Les Hanak.)

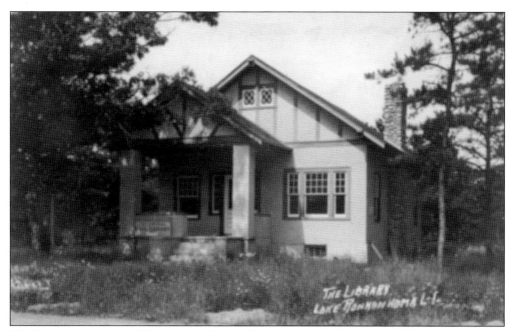

The Ronkonkoma Free Library was built in 1916, and it was originally in the home of suffragist Lillian DeVere. As the popularity and the number of books increased, DeVere was able to convince the New York State Education Division to approve the founding of a library in Lake Ronkonkoma. George C. Raynor and W.N. Hallock donated a plot of land 40 by 100 feet by on Hawkins Avenue. A design for a small, one-bedroom house found in the October 1915 issue of *Ladies Home Journal* was modified and used to construct the new library. The Lake Ronkonkoma Free Library was renamed the Sachem Public Library in 1961 to take on the name of the school district. It operated out of this location until 1965, when a new larger library was built about a mile away on Holbrook Road. Since 1976, the building has housed the Lake Ronkonkoma Historical Society Museum.

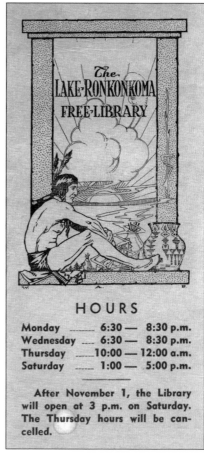

HOURS

Monday _____ 6:30 — 8:30 p.m.
Wednesday ____ 6:30 — 8:30 p.m.
Thursday _____10:00 — 12:00 a.m.
Saturday _____ 1:00 — 5:00 p.m.

After November 1, the Library will open at 3 p.m. on Saturday. The Thursday hours will be cancelled.

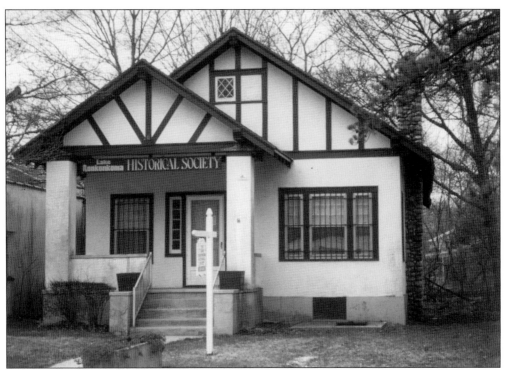

The Lake Ronkonkoma Historical Society was organized in 1976 by Ann Farnum Curtis and a group of local residents. Curtis arranged to lease the vacant 1916 Lake Ronkonkoma Free Library building on Hawkins Avenue, and after two years of renovations, the Lake Ronkonkoma Historical Society Museum held its grand opening on October 1, 1978. The museum was granted its absolute charter on November 17, 1989, and still serves the community today. Pictured below at the grand opening are, from left to right, Patricia Veprovsky, Ann Farnum Curtis, and Patrick Smith.

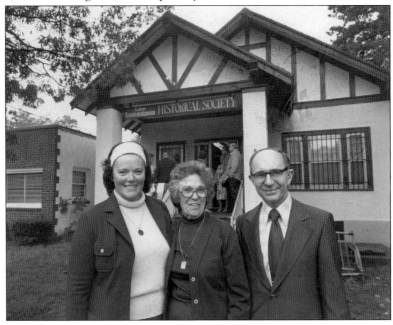

Six

PEOPLE AND HOMES

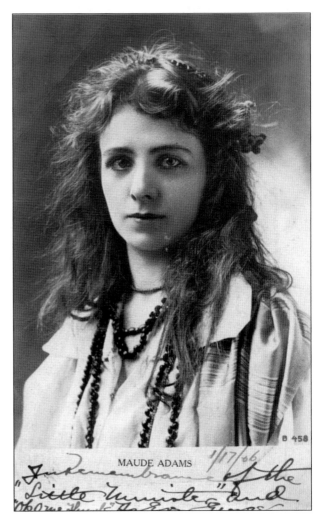

MAUDE ADAMS

In 1898, Maude Adams bought a home in Lake Ronkonkoma from a friend she had visited there. She named the home Sandy Garth and bought the surrounding land until she had an estate of more than 400 acres, which she operated as a farm. Sandy Garth was Adams's refuge from the world of Broadway stardom, of which she was a part from the 1890s through the 1920s. This 1906 postcard shows Maude Adams dressed as Lady Babbie from her highly successful Broadway play *The Little Minister*.

George Renwick Raynor (1898–1973) was the son of George C. Raynor. Renwick, as he was known to most people, operated the Raynor's Lakeview Beach complex with his father and married Dorothy Chipp in 1920. They had two children, George Stuart Raynor in 1921 and Shirley Raynor in 1923.

Shirley Raynor and her brother, G. Stuart Raynor, are shown here in 1928 next to some of the bathhouses built up on the hill at Raynor's Beach Park. Shirley would go on to work for the Sperry Corporation, where she helped to develop the first instrument-landing system used during World War II. They are shown playing in front of the 1927 Chevrolet owned by local restaurant owner Margaret Curtis.

Helen Hethy, age three, is shown here outside one of the changing rooms at Raynor's Beach Pavilion in 1945. Hethy grew up to be a teacher, teaching in the Sachem School District's Nokomis School. She has also gained an impressive reputation as a local history researcher.

Lifelong Lake Ronkonkoma resident Emma Bruno is seen enjoying the beach in the summer of 1947. She was a co-owner of Bruno's Beverage in Ronkonkoma. Behind Emma are Raynor's Pavilion (to the left) and the Green Pavilion (on the right).

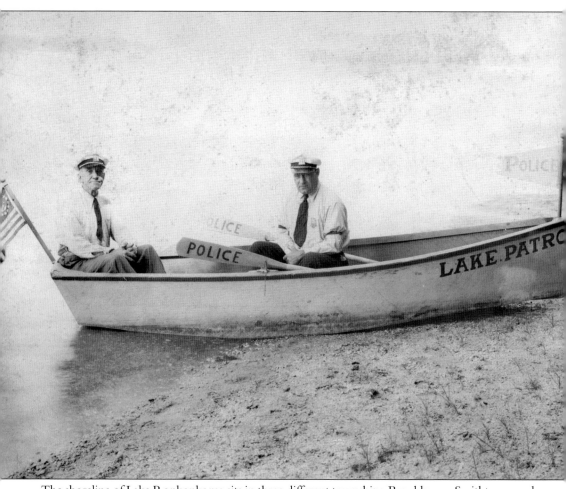

The shoreline of Lake Ronkonkoma sits in three different townships, Brookhaven, Smithtown, and Islip. After gasoline-powered boats were permanently banned from the lake in 1934, it was decided that only one of the towns would be responsible for law enforcement on the waters of the lake. Islip Township was chosen, and pictured here is an Islip Lake Patrol Boat. The patrolmen in the boat are former New York City police captain Frank Rohrig (left) and Bill Enders.

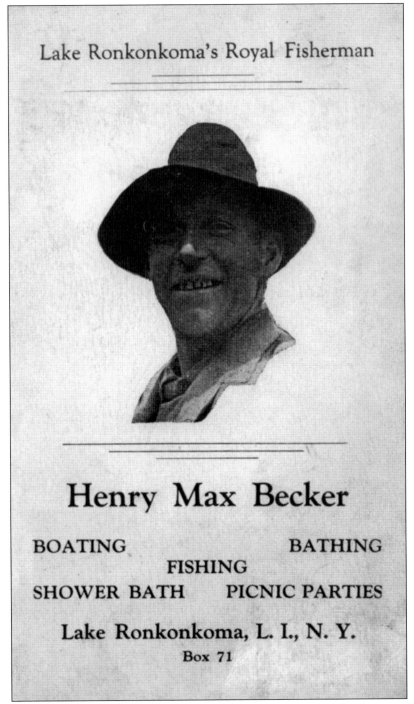

Lake Ronkonkoma's Royal Fisherman

Henry Max Becker

BOATING BATHING
FISHING
SHOWER BATH PICNIC PARTIES

Lake Ronkonkoma, L. I., N. Y.
Box 71

Henry Max Becker was a colorful character who loved fishing in Lake Ronkonkoma, and he had a small dock along the east shore of the lake. The tourists who stayed at the nearby Lake Front Hotel were not experienced with fishing in a large lake, so Max set up a fishing station to capitalize on this business opportunity. The business kept growing to include showers, swimming on the beach, and a picnic area. It eventually became Becker's Beach and Hotel.

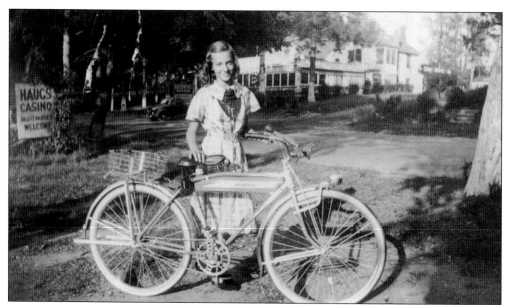

Edward and Louise Haug opened Haug's Casino Beach on the east shore of Lake Ronkonkoma in 1925. The small beach and casino pavilion operated for 20 years, and the Haugs raised five children. The photograph above taken in 1936 shows daughter Ruth Haug standing next to the family business on Pond Road, with Jack Brown's Tavern in the background. In the photograph below, Henry Haug, the oldest son, sells hot dogs on Pond Road at the old Haug's Casino location. Uncle Henry, as everyone knew him, was a walking encyclopedia of Lake Ronkonkoma history and always had a story to share.

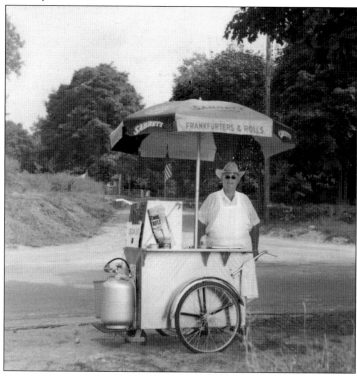

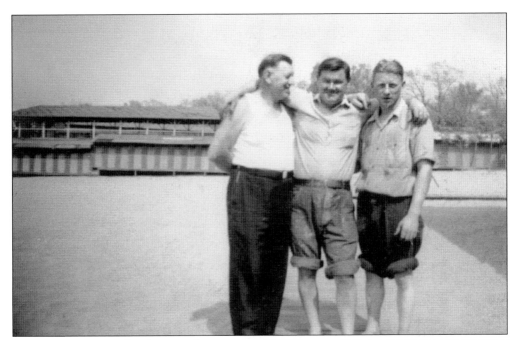

Charles Kruger owned and operated the Hollywood Pavilion on Pond Road. The pavilion operation was a family affair, with Kruger's son and family housed in the pavilions living quarters during the season. Pictured here from left to right in front of the Hollywood are Larry Anderson, a longtime friend and lifeguard at Hollywood, Charles Kruger, and Bernie Torak. Hoyt's Beach Pavilion and changing rooms can be seen in the background.

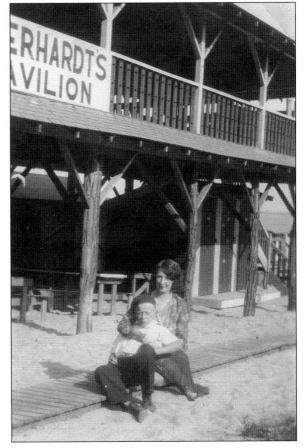

This image from about 1926 shows Susie Eberhardt Bliemiller and William Eberhardt sitting in front of Eberhardt's Pavilion. Eberhardt's Pavilion was located on the north shore of Lake Ronkonkoma.

Bill Agnew moved to Lake Ronkonkoma when he was six years old after his father James Agnew purchased the W.E. Coleman General Store. Bill worked along with his brother Jim and later with their sister Elizabeth in Agnew and Taylor, which he later inherited. Bill also worked for Hollis Newton on his farm and did yard work at the Silver Birches, a retreat house on Wittridge Road. Before work, Bill would go fishing in the early morning at Lake Ronkonkoma.

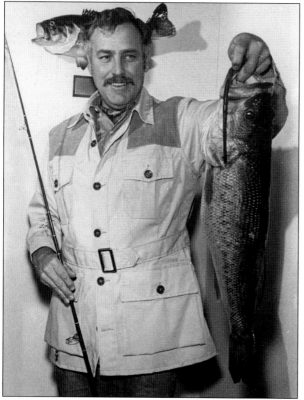

William Bartik, DDS, was an avid fisherman as well as a local dentist, pictured here with one of the gigantic bass caught in Lake Ronkonkoma. At one point, Bartik held the record for largest bass ever caught in the lake.

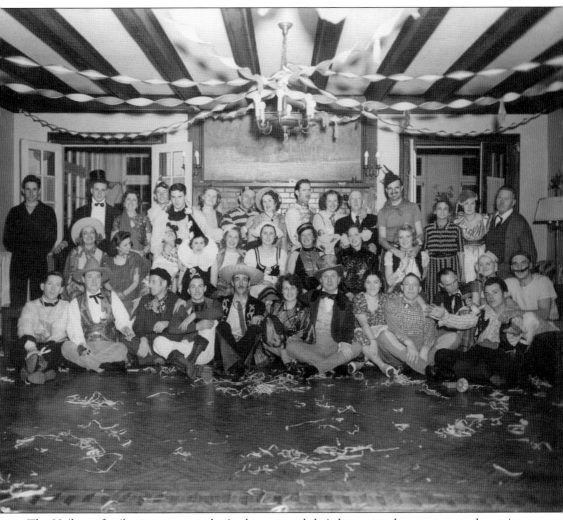

The Heilman family was very popular in the area, and their house was host to many gala parties over the years. Everybody seems to be having a grand time at this costume party.

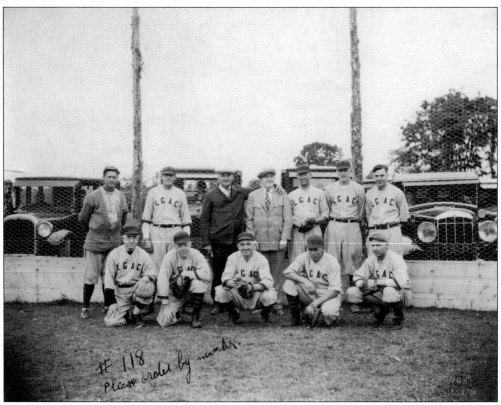

Baseball was an important part of social life in the town of Lake Ronkonkoma. By 1890, local teams were formed; the Ronkonkoma baseball team, the Lake Grove Athletic Club, and the Hawkins Nine were early teams. The image above features, from left to right (first row) Stanley Hawkins, Joseph Manning, Charles Hawkins, James McDonald, and Richard B. Newton; (second row) Samuel Hope, Otto Becker, Emil Becker (manager), Joseph Kirk (president), James Davis, Charles Sinrad, and Frank Reynolds. The image below was taken at a Hawkins Nine reunion on September 15, 1935, at the Riverhead Fair of Suffolk County.

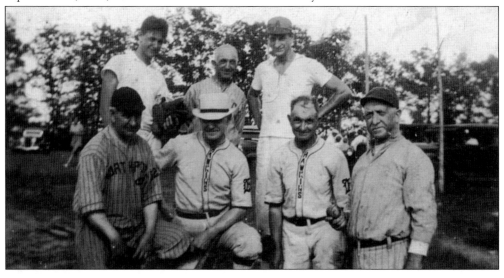

This rare image at right shows Les Hanak standing on the bridge over the railroad tracks at Ronkonkoma Avenue in 1937. The two-lane bridge was built in 1912. Ronkonkoma Train Station No. 2 can be seen in the background; notice the wood-plank roadbed on the bridge. Les Hanak grew up in Lakeland just south of Lake Ronkonkoma, and he loved fishing, swimming, and iceboating. He was also a member of the Lakeland Fire Department and a devoted baseball player. He and his brothers played for the Ronkonkoma Cardinals, and Les helped organize the Ronkonkoma Pirates, who would play on the southeast corner of Ocean and Johnson Avenues in the Lakeland area. He is shown in the image below (third from left) in front of the Green Pavilion; on the left is his future wife, Emma. The Raynor's Lakeview Beach hilltop area can be seen in the background.

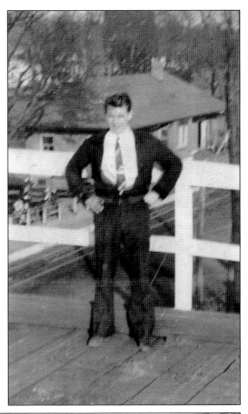

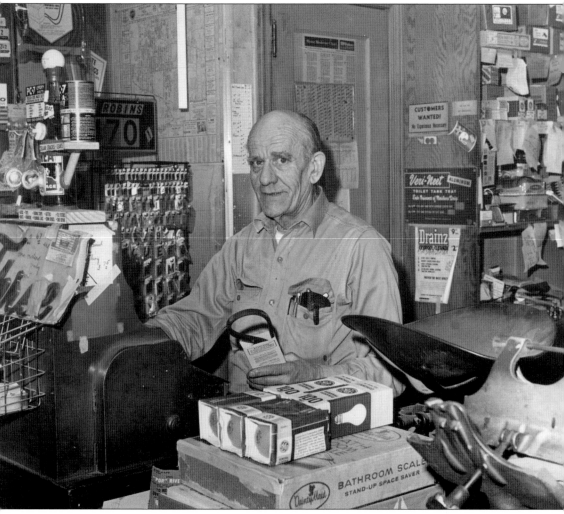

In this image, Harry Robins is standing behind the counter in the Robins Hardware Store. Robins first opened for business in 1933 on the east side of Hawkins Avenue.

Louis Heilman, pictured here in front of the bank building, was one of the original directors of the First National Bank of Lake Ronkonkoma. The bank operated successfully though the Great Depression.

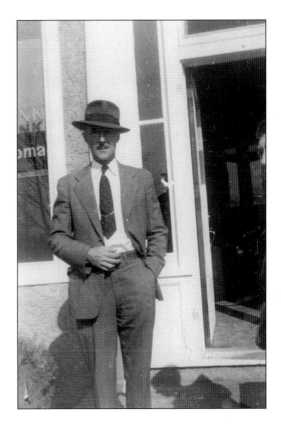

Ralph B. Wheeler was the first cashier when the First National Bank of Lake Ronkonkoma opened its doors on April 9, 1928. He faithfully served the depositors for over a decade.

Charles Wheeler Hawkins (1835–1896), pictured here in 1892, was the son of Mills Hawkins, and he grew up at the Hawkins Homestead on Gatelot Avenue. Mills' wife, Jane, had inherited the homestead in 1825. It had earlier been known as the Smith Tavern location. Charles Wheeler was a justice of the peace and a local grammar-school teacher.

This photograph of the Hawkins brothers was taken on February 15, 1890. They are, clockwise from top left, Ernie, Morris, Stanley, and Charlie. They are the children of Charles Wheeler Hawkins and Mary E. Hawkins (Newton).

Various Hawkins family members got together to play dominoes on Saturday nights, a favorite family pastime. The Hawkins family members shown here are, from left to right (first row) Sam, Morris, and Stan; (second row) Charles Willis, Mame, and Richard. (Courtesy of Quinn Vollgraff and Les Hanak.)

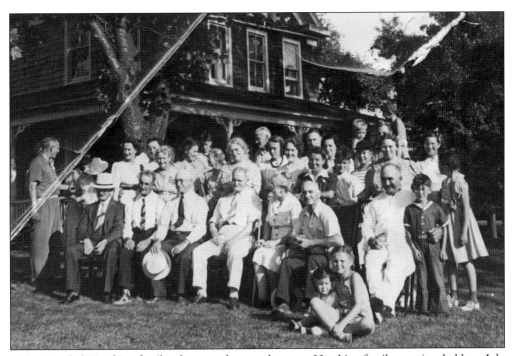

This extended Hawkins family photograph was taken at a Hawkins family reunion held on July 26, 1941. The Hawkins family was important in Lake Ronkonkoma, as they owned much land and held many important positions in the town. Many of them were farmers, teachers, and involved in local politics. Hawkins Avenue, a main thoroughfare in the town, is named for them. The Hawkins brothers are lined up in the first row; from left to right are Sam, Morris, Stan, Ernie, sister Mame, Charles and Richard.

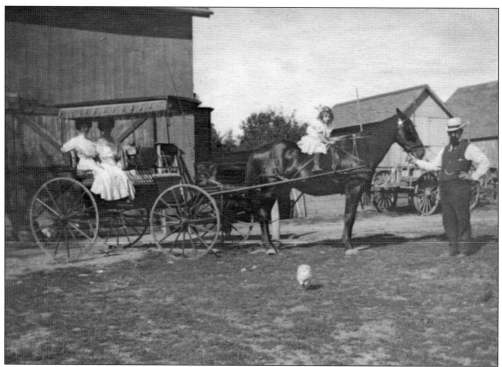

In 1888, Fitz-Green Hallock and his wife, Cassie, built the Hallock Homestead on Pond Road, where raised five children. Fitz-Green became a local butcher, harvested ice from Lake Ronkonkoma for an ice business, sold insurance, and organized crews for road improvements. He also rented rooms in the summer to people who came to vacation at Lake Ronkonkoma. In the photograph above, the family is preparing for a Sunday outing in the family's prized surrey. Katharine "Babe," the youngest child, is sitting on Jerry the horse with Fitz-Green on the right. In the image below, William Merritt Hallock and his sister Millie enjoy a ride in the family sleigh.

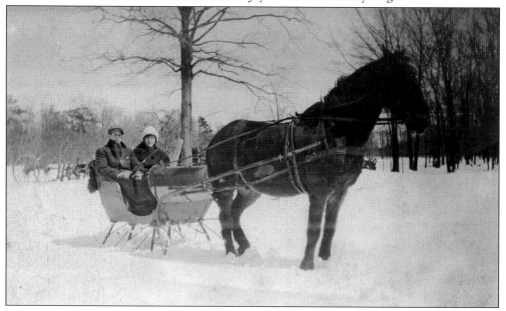

Maude and Millie Hallock pose in front of the barn at the Hallock Homestead in brother William Merritt's World War I Army gear. Heartbreak would strike the family in 1917 when William was killed in action in France.

In 1995, the last surviving daughter of Fitz-Green and Cassie Hallock, Babe, donated the Hallock Homestead, complete with all the original furnishings, to the Lake Ronkonkoma Historical Society for use as a museum. This June 1996 photograph taken in the Homestead features, from left to right, volunteer Gloria Clifford, Lake Ronkonkoma Historical Society president Marjorie Raynor, Katharine Hallock Kenneth, and trustee Patricia Veprovsky.

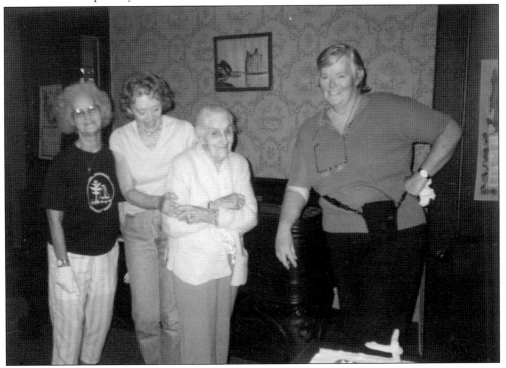

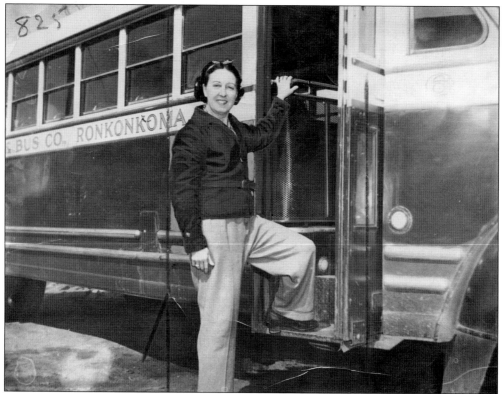

Dot Hawkins operated the Hawkins Taxi and Bus Company for 21 years, and this was the bus she drove for the last few years of her career. This photograph appeared in a story about Hawkins's retirement in the *New York Daily News* on March 29, 1942.

This home was built overlooking Lake Ronkonkoma in 1917. The Heilman family sold the home to Jacob Ross, and he began to operate a small bed-and-breakfast with a café in the building he called the Lorelei. The house is still standing and is home to a talented woodcarver named Todd Arnett, who creates custom-made statues from tree trunks.

Sam Hawkins operated a general store in Lake Grove at the corner of Hawkins Avenue and Moriches Road. He built and then expanded the family home, pictured here around 1909. Sitting on the lawn are, from left to right, Helen Marjorie Hawkins, Audrey Hawkins, Bea Hawkins, and Malcolm Hawkins. The home is still owned by the Hawkins descendants to this day.

This home was built by Adolph Weichers on the north side of Smithtown Boulevard, near Spectacle Lake. It featured amazing Italian gardens with walkways lined with many varieties of plants and flowers as well as a large windmill. The house was enlarged and improved numerous times. Young Ardie Brown loved to ride the beautiful sculpture on Weichers's front lawn, as captured by photographer Robert S. Feather below.

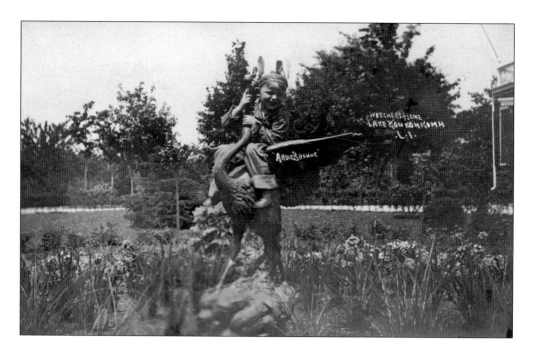

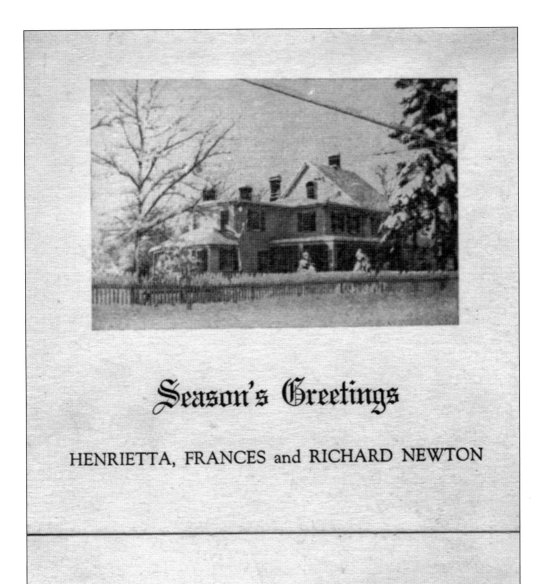

Season's Greetings

HENRIETTA, FRANCES and RICHARD NEWTON

The Newton Homestead on Portion Road is one of the oldest houses in Ronkonkoma, with the oldest section dating back to 1796. In 1915, the Newton House was the first in town to have electric power. This Christmas greeting card features a gorgeous winter view of the homestead.

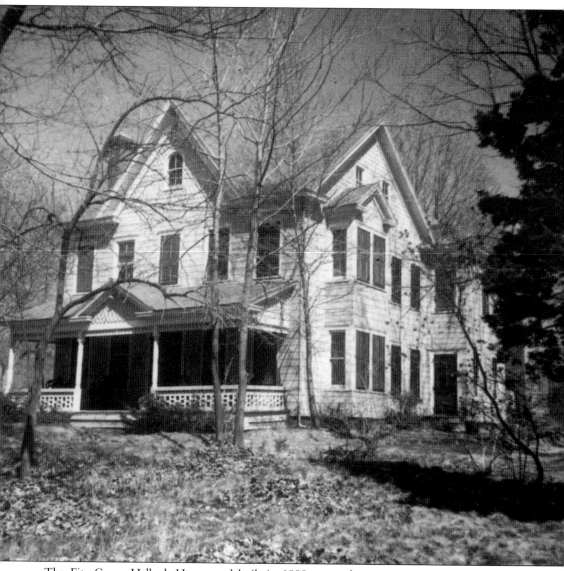

The Fitz-Green Hallock Homestead built in 1888 currently serves as a museum for the Lake Ronkonkoma Historical Society. The original furnishings are still in place in each room. Various events, including house tours and a Victorian tea, are held at the historic homestead every year.

ABOUT THE ORGANIZATION

The Lake Ronkonkoma Historical Society is a 501c charity granted an absolute charter by the board of regents of the University of the State of New York on November 17, 1984, to act as the official organization concerned with preserving and honoring the history of Lake Ronkonkoma, Lake Grove, Lakeland, and Nesconset. The society currently operates two museums: the Lake Ronkonkoma Historical Society Museum located at 328 Hawkins Avenue, Lake Ronkonkoma, and the Fitz-Greene Hallock Homestead Museum located at 2389 Pond Road, Lake Ronkonkoma, New York. Contact us for questions, tour information, special programs, or to make a donation:

Lake Ronkonkoma Historical Society
P.O. Box 2716
Lake Ronkonkoma, New York 11779
Phone: 631-467-3152
Email: Lakeronk328@optonline.net
Visit our website at www.LakeRHS.org.

DISCOVER THOUSANDS OF LOCAL HISTORY BOOKS FEATURING MILLIONS OF VINTAGE IMAGES

Arcadia Publishing, the leading local history publisher in the United States, is committed to making history accessible and meaningful through publishing books that celebrate and preserve the heritage of America's people and places.

Find more books like this at
www.arcadiapublishing.com

Search for your hometown history, your old stomping grounds, and even your favorite sports team.